Contents

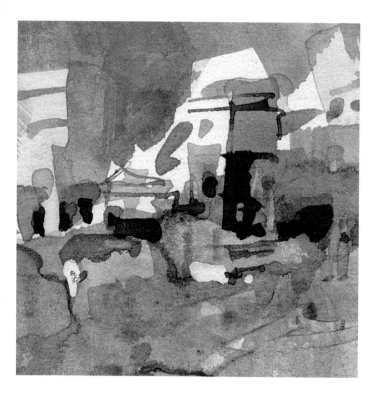

This suggestive representation leaves plenty of room for imagination.

Introduction

This is not simply another book on learning how to paint. It covers a far broader area than the many good books dealing with the techniques of figurative or abstract painting. It deals with the grey but nevertheless colourful area between the figurative and the abstract – the loose and impressionistic style of painting that leaves much to the imagination of the viewer.

This is painting in which the subject is recognisable, but is a long way from the photographic approach; it is work painted with freedom and fluency that stimulates and excites the viewer and forces him or her to use their own imagination.

'Logic will get you from A to B. Imagination will take you everywhere.'
Albert Einstein

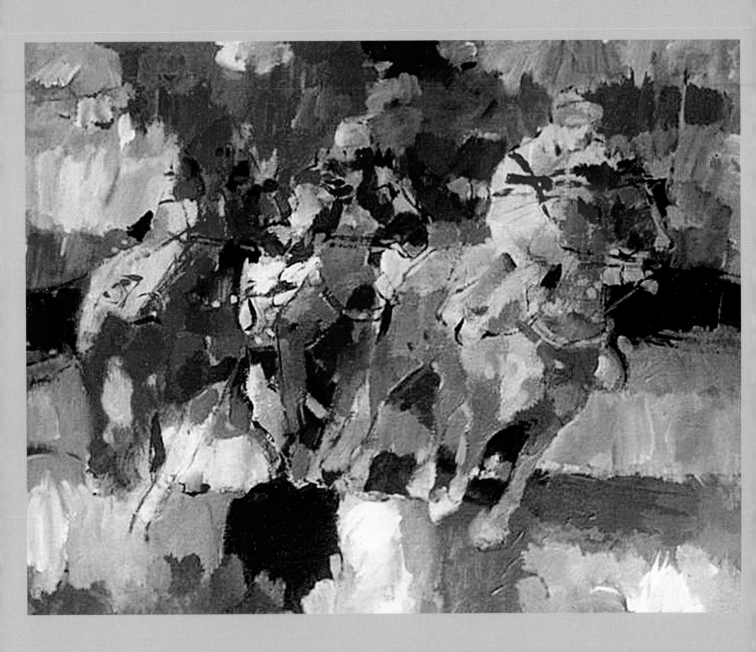

Jacques Wesselius
Acrylic
The fluid touch of this artist excites the imagination. The clear texture of the brushstrokes contributes to the vitality of this beautiful work.

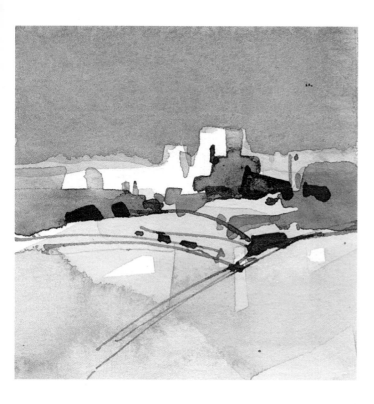

With just a few lines and colours, a realistic picture is created.

Even if you are a skilled artist, the work you produce may not be very different from that of other artists, and there is plenty of this type of work around.

Realistic abstract painting will gradually allow your creativity to slowly unfold. You will develop your own visual palette with which you will learn to express yourself in your own individual style. Use the valuable advice in this book to help you find new ways of looking at colour, form and composition.

*'No great artist ever sees things as they really are.
If he did, he would cease to be an artist.'*
Oscar Wilde

Viktoria Prischedko
Watercolour
A dreamy mood is evoked here using wet paper. The strong accents contrast with this mood and even reinforce it.

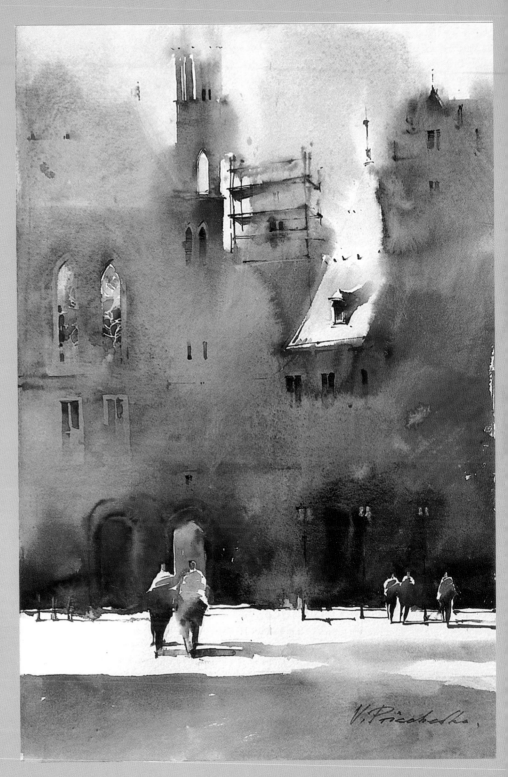

The minimum of pictorial material is used here to suggest a reality.

With this unique method, you will come to paint in the same way that you listen to music or read poetry. By portraying just the essence of a scene you get to the core of your subject, allowing you to touch the viewer more directly.

'What's best in music is not to be found in the notes.'
Gustav Mahler

Xavier Swolfs
Watercolour
This poetic abstract watercolour breathes with an almost musical rhythm.

This picture is almost a notation in flowing handwriting.

This challenging method is aimed chiefly at the experienced painter. Examples from every form of water-based media will be used, including acrylics as well as watercolours.

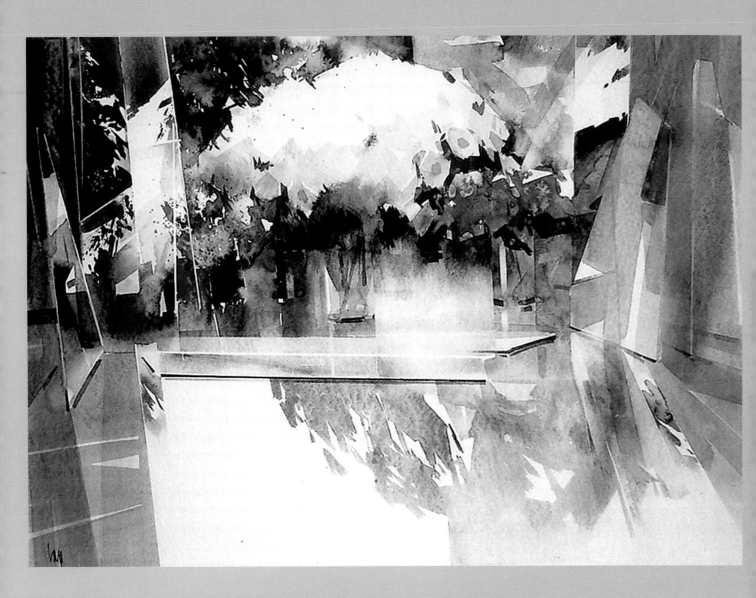

Piet Lap
Watercolour
*This artist has portrayed his own reality
in a stylised form.*

Often a painting is totally abstract. Balance, form and colour contrasts are the decisive factors here. The figurative element is added to create a work of abstract realism, evoking positive recognition in the viewer (detail from the picture on the opposite page).

What do we mean by 'abstract art'?

Art as medicine

Painting is far more straightforward than you think. All you need to produce an attractive work of art is knowledge of a few simple, basic rules.

Up to now, you may well have been producing skilful work: landscapes, still lifes and so on. If you are happy with your current style of painting, fine. But for those who have been toying with the idea of learning to paint more loosely and fluidly, this book may be just what you need.

Painting realistic abstracts will bring a sense of excitement into your artistic life and guide you towards a sense of freedom in your painting that you would not have believed possible. It is my hope that this book will awaken in you a sense of spontaneity and freedom that will cure you of slavishly copying reality. In a nutshell: art as medicine.

Johan Meeske
Watercolour
Flowing spontaneity is used here to evoke a suggestion of reality.

The basis of this realistic scheme is nevertheless abstract. Contrasting colours and tone, a diagonal movement that gives the whole picture dynamism and a well-balanced distribution across the surface of the picture – all these elements are more important than the apparent reality on which the work is based.

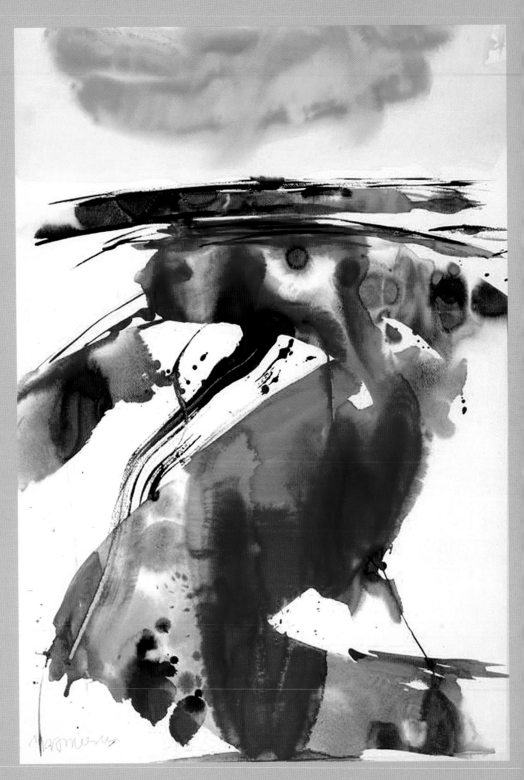

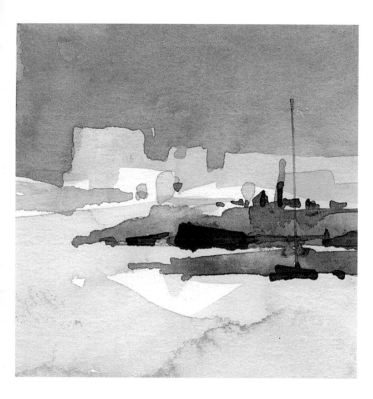

Visualisation

You may be surprised that I begin this book about abstract, fluid and spontaneous painting with a chapter on learning how to see and draw accurately. Let me explain.

In our civilised society, an excess of rules and regulations can have an oppressive effect. Our culture of performance and competition does not encourage tranquillity. Even in our free time, we pursue competitive sports in the name of relaxation.

The genuine relaxation that you can achieve with this form of painting has nothing to do with high performance. Even more importantly, you do not need to learn anything to accomplish it.

Kees van Aalst
Acrylic

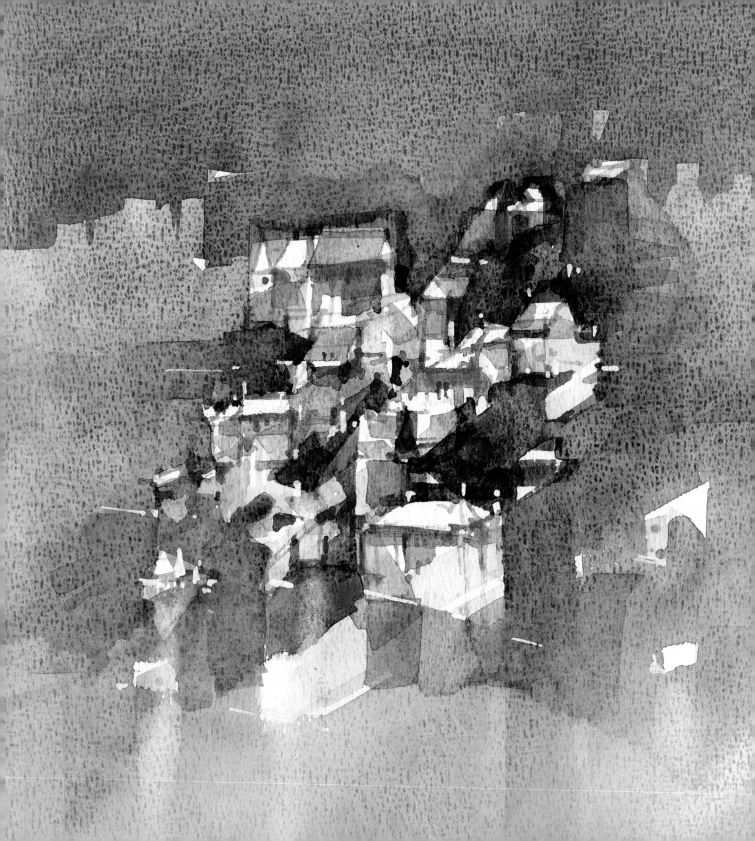

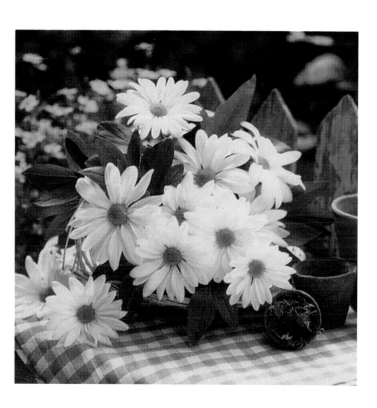

What will you need to produce abstract art? A piece of paper, a pencil and a quiet spot. Also the innocence and frankness of a childlike eye. Someone once said that at birth, everyone has an artist within them who sees the light, dies young and then lives on as an adult. The adult still has eyes but no longer sees; at best he or she just looks.

So how can you achieve that innocent eye; how do you learn to see again?

Begin by taking a simple object that appeals to you, for example a flower. Leave your pencil and paper alone and observe the flower. Look at it closely, let your eyes follow its outline and, in an internal dialogue, sketch the object something like this: 'a line runs diagonally upwards in a smooth movement and is twice as long as that dark area perpendicular to it, which is oval in shape'. Think only in terms of lines and shapes. Once you have explored the object like this, you can move on to the next stage: visualisation.

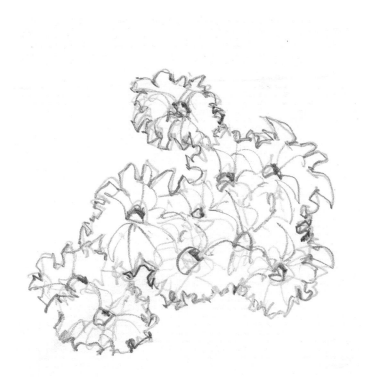
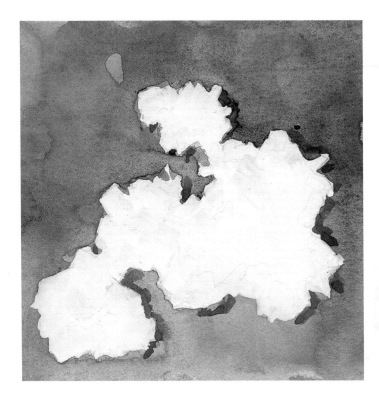

The flowers drawn 'blind' in pencil and, next to them, the broad, overall shape that we need to keep in our mind's eye.

To visualise an object, look closely at it again, then shut your eyes and try to 'see' it in your mind. This may not work straightaway but after a few attempts you will definitely be able to evoke an image. After this visualisation exercise, you can move on to an actual drawing. With a pencil in your hand, look at the object, conduct your internal dialogue once more and, without looking at the paper, hold the pencil so that it is touching the paper at all times. Your hand will thus be tracking your thoughts 'blind' on the paper. Try to transfer the lines, shapes and directions you describe in your internal dialogue on to the paper. The result will not be a precise representation of the object, but that does not matter at this stage. What is important is that you have learned to observe with great concentration and attention. You are learning to see instead of superficially looking.

The last stage is to move the object that you are now familiar with from your head on to the paper. Look away from the object and draw what you see in your mind's eye. Leave out all the trivial details and set down only the essence of what you see.

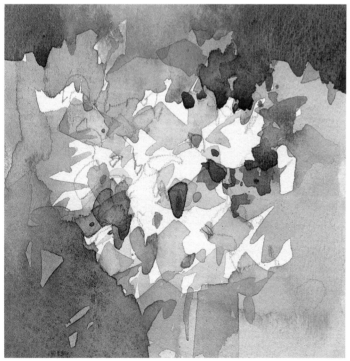

Above you can see an impression of the motif in felt-tip pen. Here we have a second version in colour. Can you see how much the result differs from the original photograph on page 16? This technique is useful in helping you to take a step back from the subject and learn to work in a looser style.

We can give our imagination so much free rein that the very character of the flower disappears. The vertical format of this painting also adds to its attractiveness.

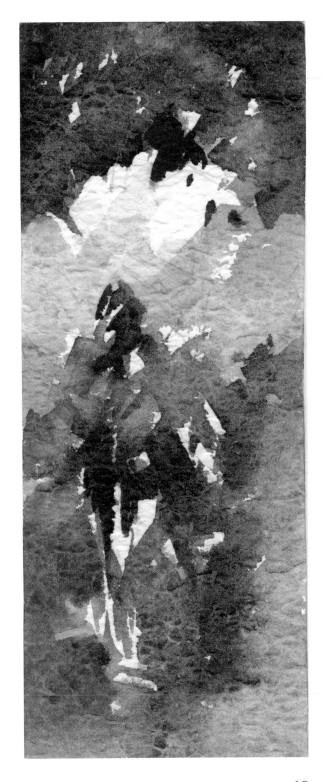

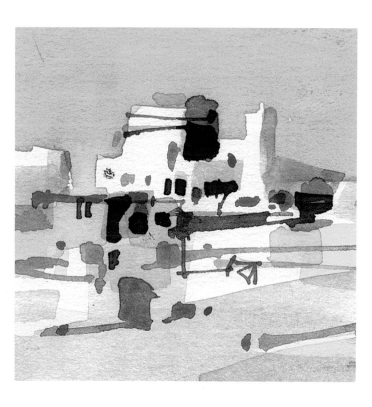

Restrain yourself as far as possible in terms of colour.

Simplification

This method of working forms the basis for bringing greater fluency and freedom into your work, distancing yourself from superfluous details and gradually developing your own style that reflects only the essence of a subject. This enables you to arrive at a transformation of reality, by elimination and taking a broad view; in short, by simplification.

The following pages present a number of examples of this approach stage by stage.

'Art only begins where imitation ends.'
Oscar Wilde

Viktoria Prischedko
Watercolour
The essence of the subject is reproduced here with a minimal amount of detail.

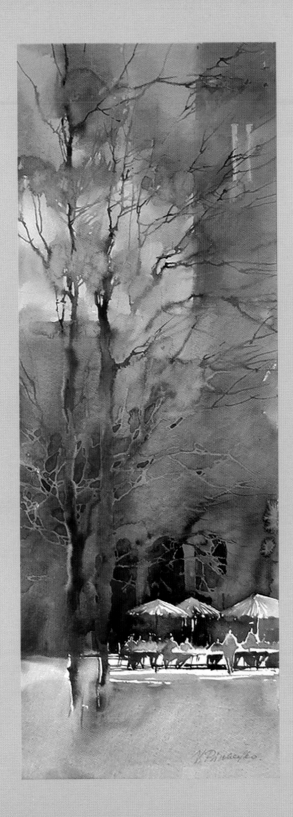

Transforming reality by means of elimination and simplification

A basic abstract composition is created in cool and warm colours, phthalo blue and burnt sienna, using a flat brush. At this stage, you should ensure unity and cohesion both in the colours and in the negative white shapes.

More form is given to the principal motif using dark halftones in cool and warm shades. The main focus here is on retaining essential white areas. Despite some suggestions of reality, the picture as a whole is kept as abstract as possible.

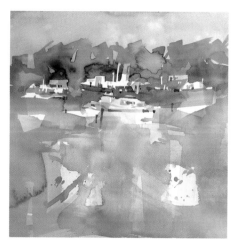

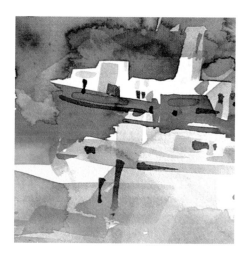

A few calligraphic accents are applied in the central section, evoking an illusion of reality. Non-figurative elements normally remain untouched within this framework, emphasising the loose, semi-figurative approach.

It may sometimes be necessary to apply a few more light details in darker areas. This can be done with white gouache or acrylic. Bear in mind that too much detail can make the work busy and untidy.

This detail shows how an abstract foundation without clearly recognisable forms can still capture the interest of the viewer.

Kees van Aalst
Watercolour

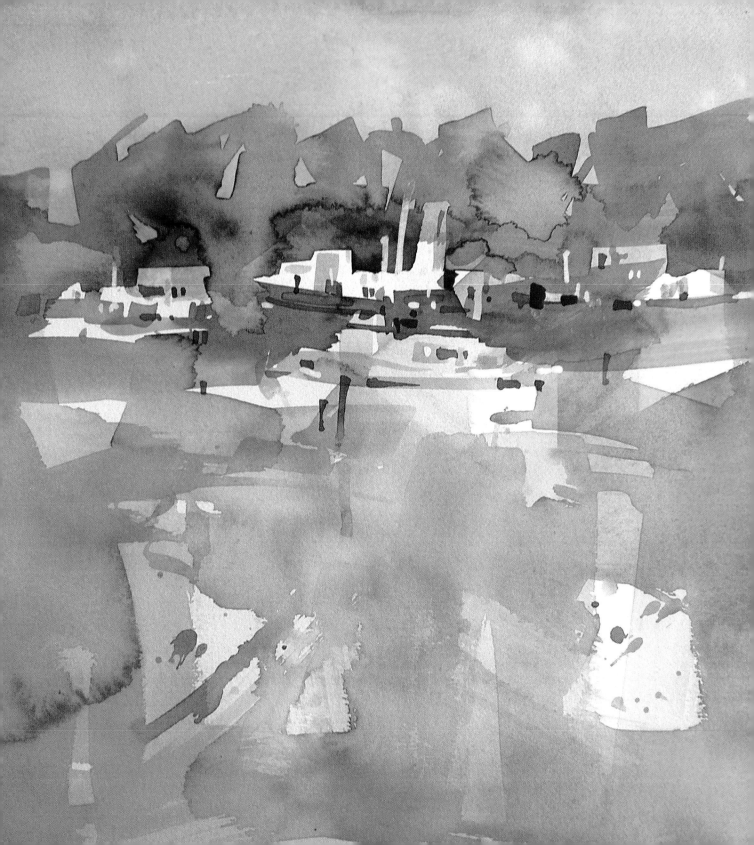

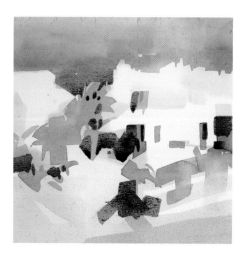

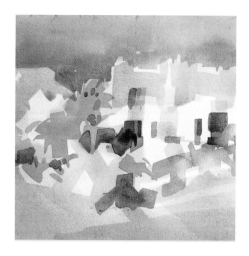

A large brush is used to apply an irregular design in a cool colour, leaving the white areas untouched. Take care to ensure that the white, negative shapes provide an interesting pattern.

A flat brush is used in the horizontal central section to bring in darker halftones. This area should not be broken up, but rather be an expression of cohesion. Make sure you use enough colour in these first stages. A combination of violet and moss green is used here.

This stage uses slightly darker tones to give the entire picture more form and allow a cohesive whole to emerge. The shapes should not touch one another but be close to each other, almost like stepping stones.

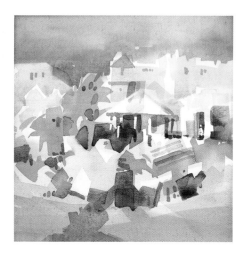

Here, the whites have been partially painted out so as to restrict the contrast between light and dark to the central section. Note how restrained the artist has been with colour. Three to five colours in a picture is often sufficient to create unity.

Kees van Aalst
Watercolour

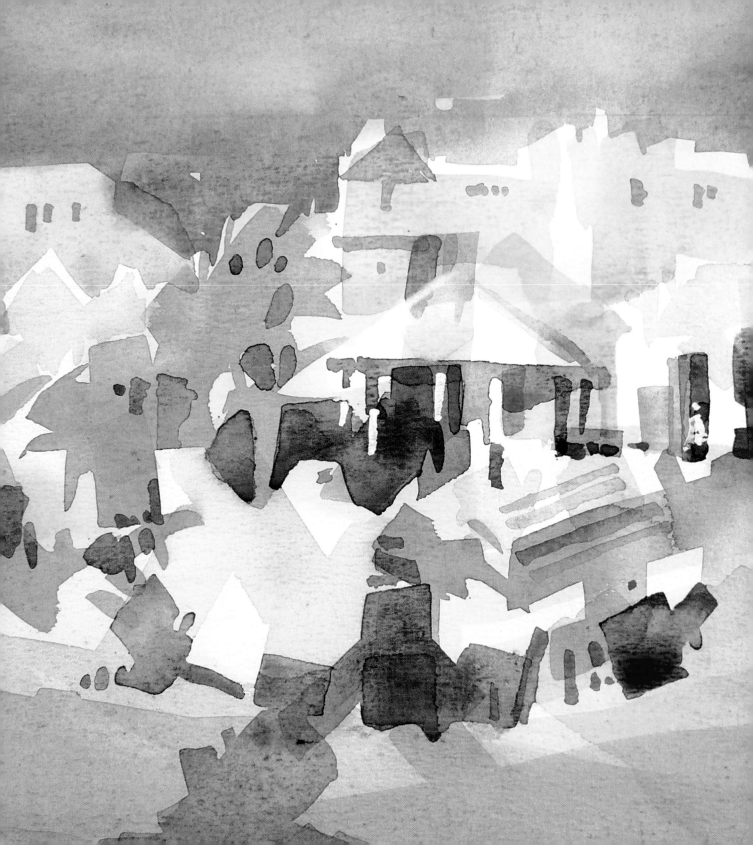

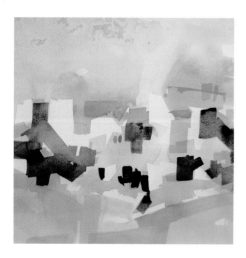

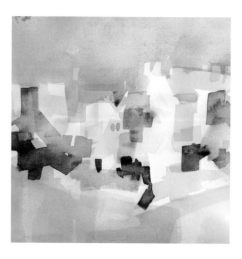

The first step is to leave the white areas blank. This sets the atmosphere and forms the basis for unity in the finished work. Both the whites and the light halftones must reveal a varied, cohesive design.

Here, the introducton of a warm tone directs attention to the central section. Change the direction of your brushstrokes here and alternate between connected and looser shapes.

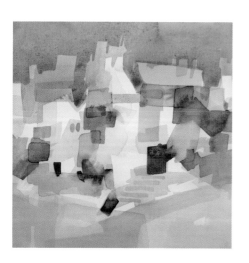

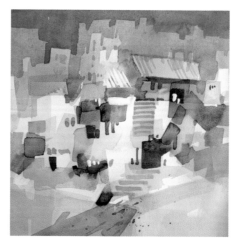

A darker tonal quality provides slightly more form to the picture as a whole. Remember to think more in terms of shapes than objects at this stage. Still keep it as abstract as possible.

The final stage provides a decorative hint of reality. Calligraphic details, applied with a rigger brush, evoke this illusion of reality. Do not let the realistic aspect dominate here.

Kees van Aalst
Watercolour

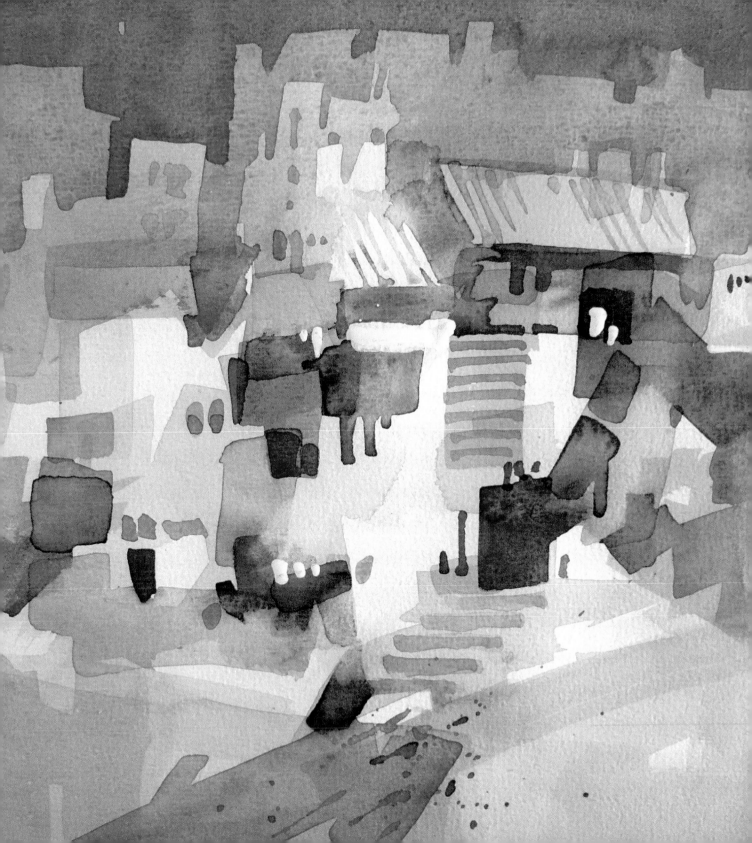

A light tonal design is applied in warm and cool colours with a flat brush, with the white sections left blank. Be careful to ensure balance and cohesion here by repeating the colours in different areas, i.e. blue at the top and then a little blue lower down, red on the left and some more red on the right.

More attention is drawn to the middle section by giving it a little more depth with the addition of mid-tone. At this stage, restrict yourself to simply painting an 'attractive abstraction'. Try to keep the hint of reality to a minimum.

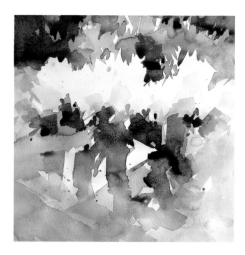

Deeper warm and cool colours will bring out the white sections to a greater extent and give more form to the picture as a whole. Notice too how the diagonals, as well as the horizontal and vertical lines, provide the dynamics of the composition.

A few final accents draw more attention to the central section. Link these accents as far as possible to the previous halftones. Do not allow them to drift into the white sections.

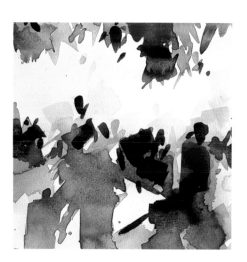

In this detailed view, we can clearly see the abstract composition, from light halftones to darker accents. The variation in cool and warm colours can also be seen clearly here.

Kees van Aalst
Watercolour

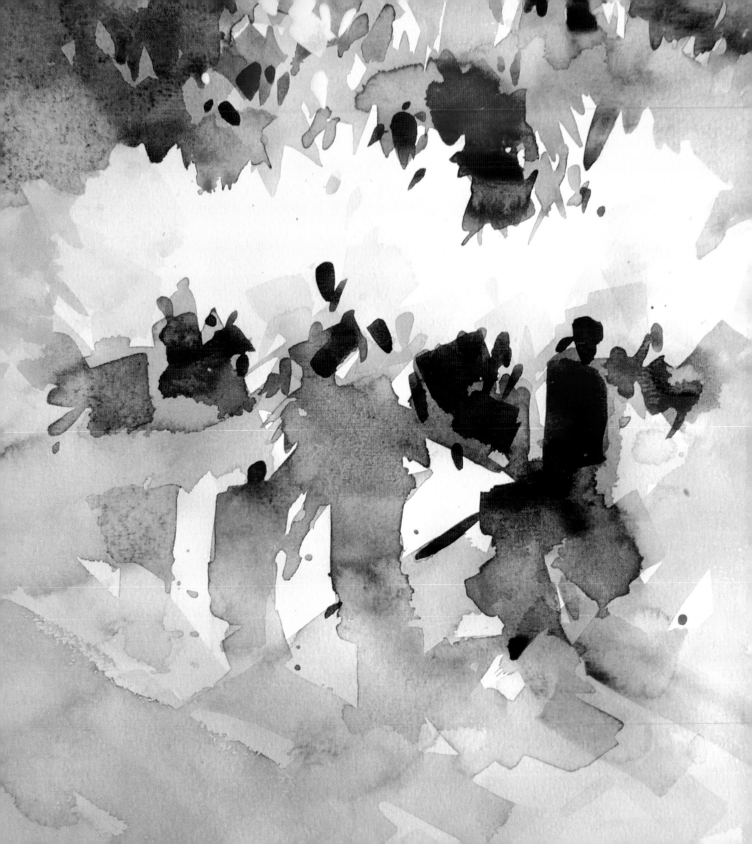

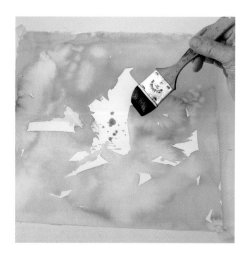

With a limited palette of colours in warm and cool tints, the blank areas have created a pattern of whites. The colours used are raw sienna, phthalo green and violet. As a basic rule, always use as large a brush as possible at this stage.

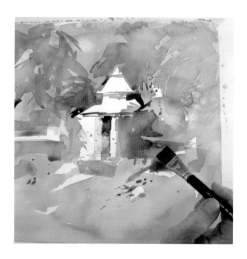

A small brush is then used with a darker tone to introduce some form to the picture. This brings out the whites more strongly.

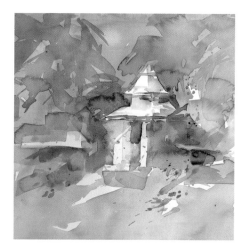

In order to prevent the white areas becoming too discrete, some nuances are applied to these light sections so they become more integrated into the picture as a whole.

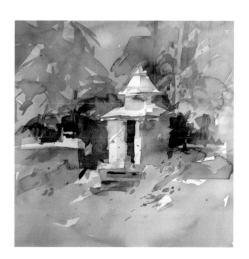

Reinforce the subject by using a few related dark tones, particularly in the central section.

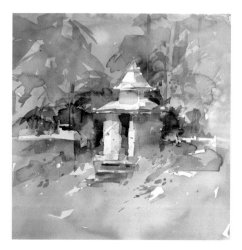

A few accents are applied with white gouache to bring the picture to life. The rest is left to the imagination of the viewer.

These detailed sections show the loose and relaxed feel of the composition. It is more a gesture than a clear illustration of reality.

Kees van Aalst
Watercolour

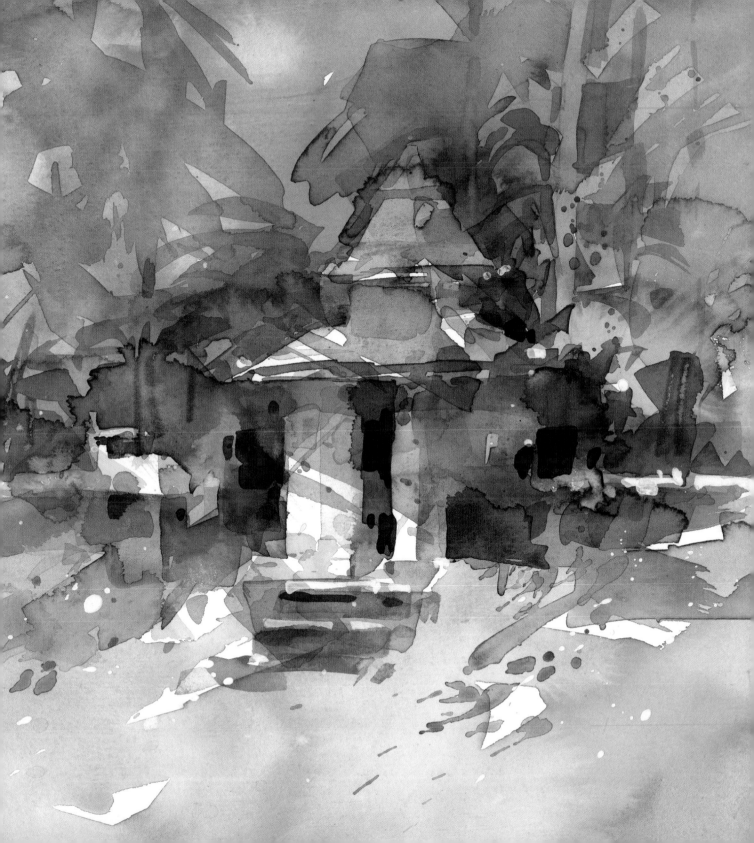

What do I need?

Materials

The choice of materials depends largely on your personal preference and method of painting. Do you prefer to work with vivid, built-up colours or would you rather use pastel tints? Do you like to work outside or do you prefer to paint in a studio? These factors will affect your choice of materials. Listing every item available is an endless task, and would require a catalogue of art materials rather than an art book. Here I will list the essential items, though I should emphasise that the materials you use have very little to do with the quality of your work. You can produce good and bad work with an expensive sable brush just as easily as with a cheap decorator's brush.

Which paint?

Acrylic

This is a versatile medium because it can be used both transparently and opaquely, and is also waterproof. One advantage of this is that a transparent undercoat in acrylic can be painted over with watercolour or gouache without any risk of the undercoat dissolving and being contaminated. Acrylic paint is available in tubes and pots. Protect your clothes because this paint is waterproof and so not easy to remove.

Watercolour

I prefer using watercolour paint from tubes. With pans I am tempted to work with brushes that are too small and to use too little paint. Water-based media require a large brush and sufficient paint for the amount of water used, particularly for the basic composition. For a colour palette I would recommend warm and cool versions of the primary colours, red, blue and yellow, plus black and white. As you can see, I am not a purist – the result is all that counts; the end justifies the means.

Gouache

Opaque gouache or poster paint is available in tubes and pots. Some painters prefer it to transparent watercolour paints because, for instance, you can apply light paint over dark areas. Illustrators, in particular, are fond of this medium. Of course, you can also combine watercolours and gouache. One reason for using such a combination is that it is an ideal method for revitalising unsuccessful watercolour paintings. Gouache can also be used as a transparent layer by diluting it further with water.

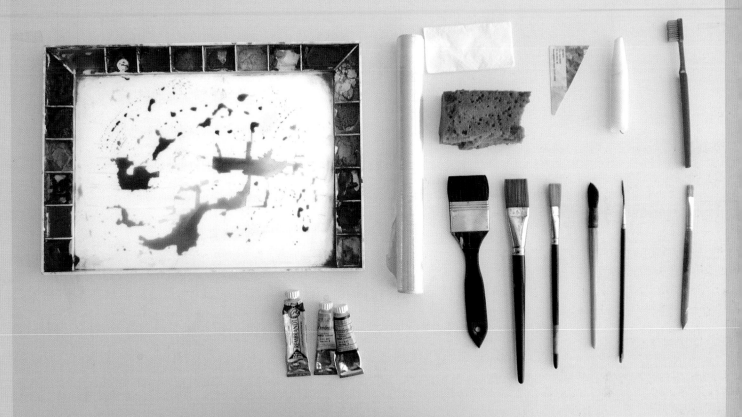

ALIZARIN/MADDER LAKE
COOL RED (contains blue)

BURNT SIENNA
WARM RED

PHTHALO BLUE
COOL BLUE (contains green)

ULTRAMARINE BLUE
WARM BLUE (contains red)

LEMON YELLOW
COOL YELLOW (contains blue)

RAW SIENNA
WARM YELLOW (contains red)

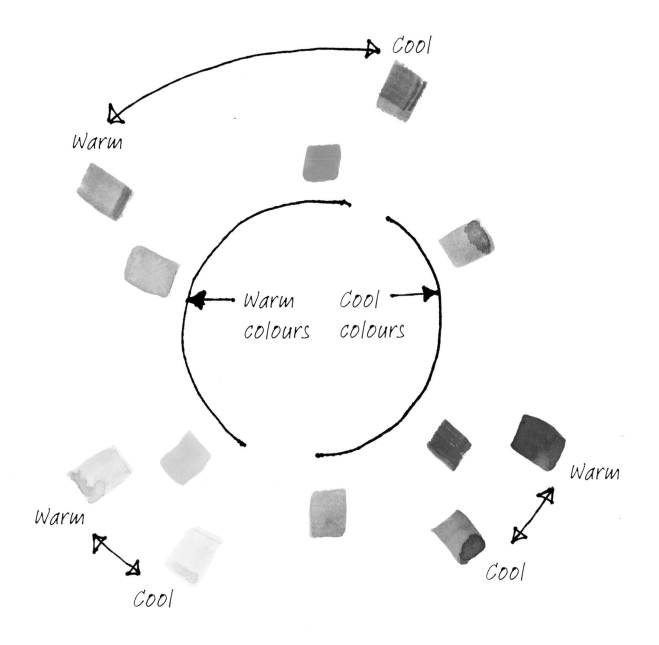

Red, orange and yellow are warm colours; green, blue and violet are cool colours.

You can see that in my palette (outermost circle), cool and warm are relative terms: cool blue is cooler than warm blue but warm blue will always be cooler than cool red.

Colours

As I said, I use a warm and a cool version of the primary colours, red, blue and yellow: alizarin or madder lake for the cool red, burnt sienna and a muted orange for the warm version. Phthalo is cool blue and ultramarine is warm blue. Lemon yellow is cool yellow and raw sienna or ochre is the warm version. I have not included violet, orange or green in my palette because these secondary colours can be easily obtained by mixing.

In reality, the choice of colours is a personal one; you might choose a far more bright or vivid palette. Magenta red, cyan blue or primary yellow, for instance: what we call 'printer colours'. In addition to the three primary colours in their warm and cool versions, I always have white and black in my palette. However, I always use them mixed with other colours so that they are well integrated into my work.

Which brush?

You can succeed or fail with an expensive sable brush just as easily as with a decorator's brush. What is important is that the brush you use is fit for purpose. For example, use a large, round or flat brush in the starting phase to avoid introducing too much detail. In the final stage, a thin brush may be useful to bring out a few accents. The choice of brush also depends on the medium. For watercolours, I often use a French squirrel-hair brush for washes, but for acrylics I prefer flat, synthetic brushes, although I also use these for other techniques. But my collection also includes ordinary decorators' paintbrushes. A hard, hog bristle brush is handy for corrections, and lastly a rigger brush for fine work.

What else?

Palette

My first choice of palette would be a large white surface, for example a tray. I use a John Pike palette for watercolours and small china dishes for gouache and acrylics.

Painting ground

You can apply paint to many diverse surfaces: paper, card, hardboard or linen, to name but a few. Although one medium may be more suitable for a specific surface, you can make any surface suitable for any medium. For example, hardboard or linen can be treated with latex wall paint or gesso first and then painted on.

With gouache you can apply light colour over dark sections. The paint can be applied either transparently or opaquely.

This picture shows how to bring an unsuccessful watercolour to life with gouache.

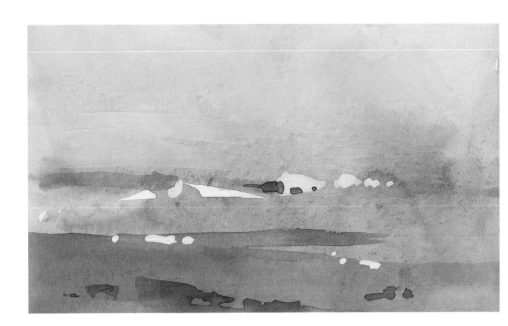

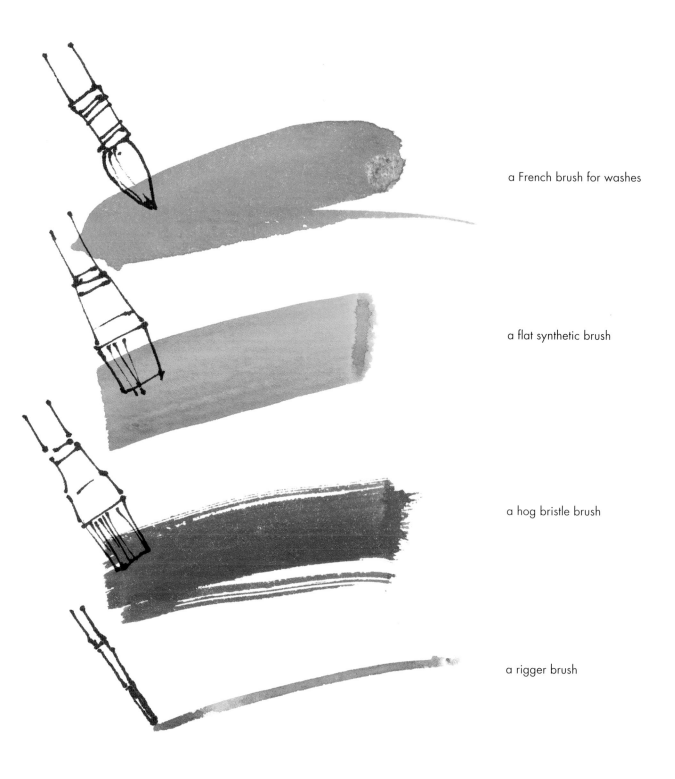

a French brush for washes

a flat synthetic brush

a hog bristle brush

a rigger brush

The different textures of watercolour, gouache and acrylic on watercolour paper.

Here, the paper has first been treated with gesso. Watercolour, gouache and acrylic were then applied.

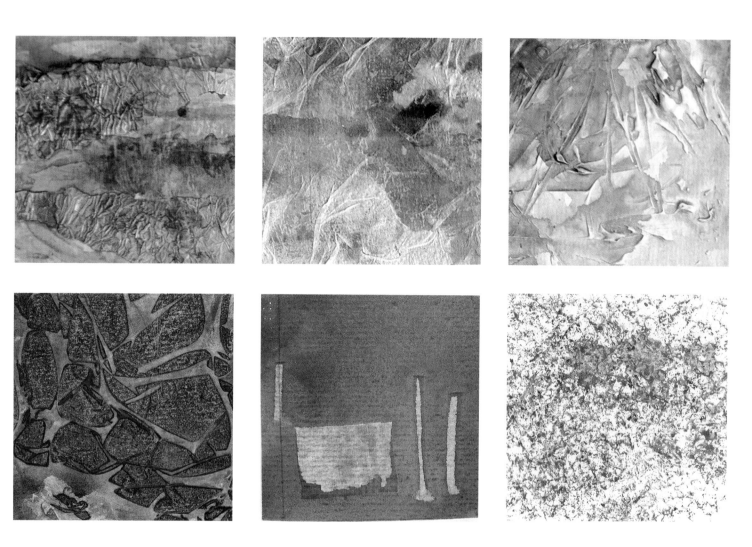

Aluminium foil, tissue paper, modelling medium, plastic food wrap, a plastic card and a sponge have been used to achieve different textures.

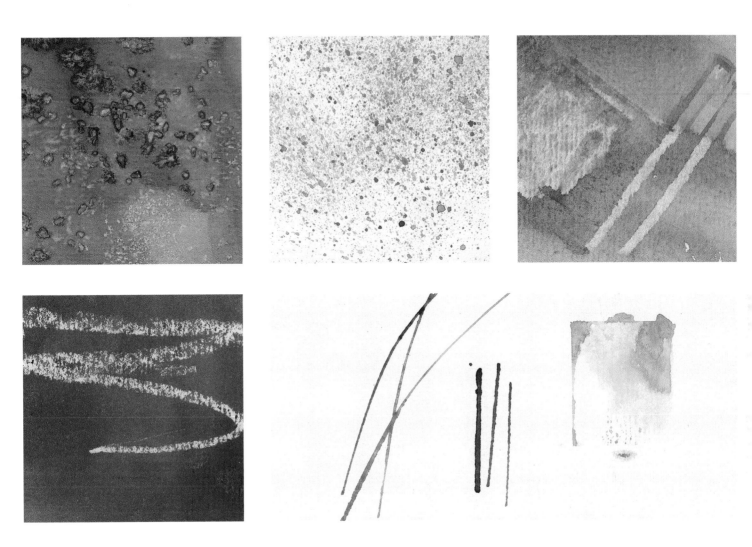

Other textures can be created with salt, spattering with a toothbrush, scraping off paint with pieces of card, using candle wax and, finally, 'printing' with shreds of paper and card.

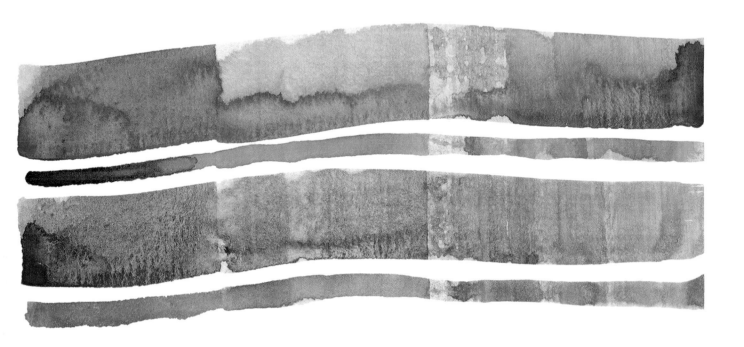

A

B

C

Watercolour paint applied to watercolour paper (A)
paper treated first with acrylic paint (B)
and treated with gesso (C)

Kees van Aalst
Acrylic

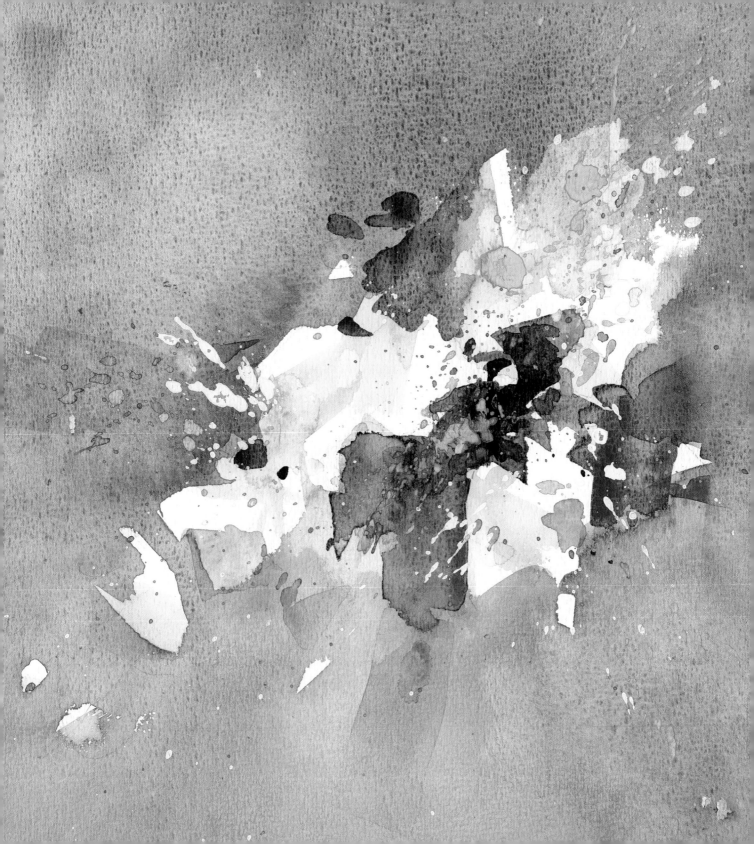

How does it work?

Realism and abstraction. An apparently unbridgeable chasm yawns between these two extremes in terms of visual representation. Realism, in which the subject is more or less depicted as it is seen, is usually easy to understand. Abstract art, on the other hand, can be a little more difficult to fathom. Both realistic and abstract art employ elements and principles of composition: in combination with reality in the case of the former. But there is an area between pure realism and total abstraction: the area of the semi-abstract, a synthesis between three-dimensional reality and three-dimensional decorative elements, a fusion between the chaos of nature and the order of composition.

Composition

Semi-abstract art demands something more of an artist than photorealism or pure abstract work. Every painter can learn to paint realistically with practice and, after a little training, produce good abstract art as well. But to combine these two extremes is a greater challenge. It is beyond the scope of this book to teach you how to reproduce reality in a photographic style, so instead I shall pay particular attention to those elements and principles on which good composition is based.

Essence

When you observe your subject closely, you will see that it is made up of trees, earth, air and so on, but your palette holds nothing but paint. Your subject is bathed in the most beautiful thing in the world: light. It also has depth and space, while paper has only two dimensions. Clearly it is impossible to imitate nature exactly; instead we have to interpret and translate it. Unless we grasp this, we will remain amateurs. We have to approach our subject with empathy, and experience what we feel about a specific subject. If we do not, the result will be a dreary and meaningless painting. There are painters who have discovered a certain technique that they use in all their paintings. Some call this their own 'style'. Be wary of over-using such methods – they will draw all the life out of your work.
To start with, we need to simplify the infinite variations of tones, colours and textures seen in nature. We must represent only the essential elements. We have to leave out anything that does not contribute to a succinct representation of the subject. We must therefore present our subject by means of suggestive symbols in a form of shorthand.

At this point I would like to delve a little deeper into the importance of tonal values. Of all the elements in a picture – line, tone, colour, texture and form – I consider tonal quality to be the most important. If we condense the infinite scale of tones in nature into three categories, light, halftones and dark, we can understand tone a little better. Let a single tone dominate. As a rule, this will be the halftones. We can now manipulate the light and dark tones in such a way that their contrasting effects draw the viewer's attention and thus direct their line of sight.

A uniform surface is unquestionably a unity, but it is a monotonous unity.

Variation in the colour has penetrated the monotony to some extent, but no unity has been achieved because of too much similarity in terms of size.

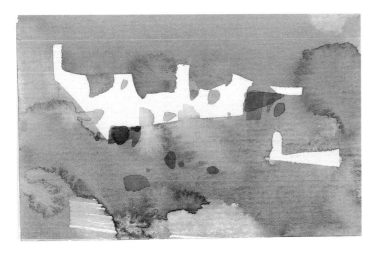

By allowing one colour to dominate and repeating elements elsewhere in the picture, a unified variety of elements has been created.

How often have you found yourself sighing: 'I am not quite satisfied with this piece of work but I do not know what is wrong with it'? In almost every case, it is not a lack of technique but a problem of composition. In other words, it is less a matter of the execution than of the interpretation. Often, a painter is unaware of a few simple guidelines that could solve the problem.

A painting can be broken down into seven elements. This is the framework in which a composition is constructed. There are also seven principles that we can use to manipulate each element. These principles of composition are to be found in every form of art. Whether we are considering music, literature or interior design, we will always come up against the need to structure reality to form a harmonious whole. The diagram below shows the elements and principles of design. Each principle can be applied to every element.

I will briefly summarise each element and principle and use illustrations to explain them. The use of these guidelines in your own work will make you aware that painting is more than simply an imitation of reality.

Principles and elements of a picture

Besides having knowledge of materials, a painter cannot work without some notion of the construction of a painting – the compositional aspect. If you are well versed in the basic rules of design, then not only will this benefit the work you do in the future but you will also be better able to recognise and analyse those parts of your previous work with which you were dissatisfied. I will not bore you in this chapter with superfluous padding and empty words. I will keep it simple and just deal with the basic necessities – the things that will be useful to you in your painting.

There are seven pictorial principles and seven pictorial elements: I will start by discussing the principles, one by one, and explain them with illustrations and examples where necessary. Then we will move on to the elements.

Pictorial principles:
The principles are: unity, contrast, dominance, repetition, variety, balance and harmony. Just as it is important for us to create some structure in our personal lives by alternating activity and rest and by setting priorities, a painting also needs a positive structure.

Pictorial elements:
These are the tools that a pictorial artist has to work with: line, tone, colour, texture, form, proportion and direction.

Forty-nine combinations of pictorial principles and elements

Principles / Elements	Line	Tone	Colour	Texture	Form	Proportion	Direction
Unity	•	•	•	•	•	•	•
Contrast	•	•	•	•	•	•	•
Dominance	•	•	•	•	•	•	•
Repetition	•	•	•	•	•	•	•
Variety	•	•	•	•	•	•	•
Balance	•	•	•	•	•	•	•
Harmony	•	•	•	•	•	•	•

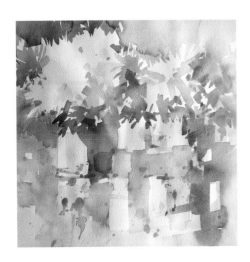

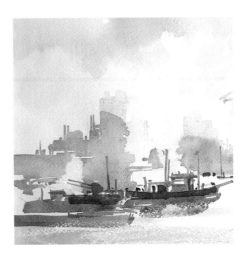

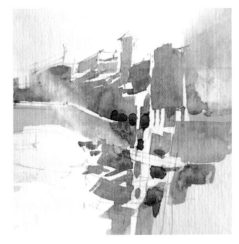

A dynamic diagonal brings the picture to life. A dominant colour and repeated shapes provide unity.

What else do you need to show to evoke the suggestion of a harbour? Notice the restrained use of colour, creating unity.

A dreamy picture in which the composition is anchored by a zigzag movement that cuts subtly through the picture. Notice the repetition of shapes that creates unity.

Unity

The most important principle of design is unity. Every element, whether line, tone, colour, texture, form, proportion or direction, must be echoed elsewhere in the work in order to ensure unity.

Unity is an integrated cohesion within our work of art. It is created by means of the repetition of elements – line, tone, colour, texture – that form a dominant factor. To keep the picture from becoming dull, we need to add a few contrasting, subsidiary elements. Thus a subject with a cool mid-tone as the dominant factor will create a unity but, in order to do so, it demands a few warmer light and dark tones as contrast, which will bring the subject to life.

Contrast in tone, colour, form and direction.

Contrast in line, tone, form, proportion and direction.

Contrast in line, tone, colour, texture, size and direction.

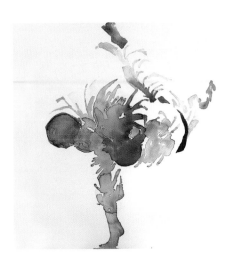

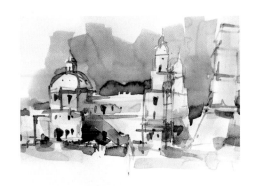

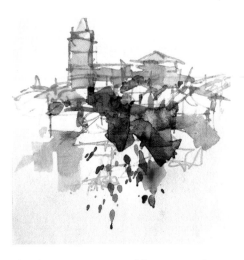

The suggestion of the Judoka (judo players) shows that the total form is more important than the separate components. Variation in direction ensures contrast.

Sketch drawn with a reed pen and diluted watercolours. The foreground and some of the sky have been omitted altogether. This creates a lively contrast.

The chaotic suggestion of the image is kept in check by the calm surrounding sections, with a contrast between cool and warm colours.

Contrast

Contrast is the tension between opposing elements. This tension introduces dynamics into your work. Try to limit the contrasts to sections to which you want to draw attention. Abrupt transitions in tonal quality or colour temperature may tire the viewer if they are applied too extensively. If we need some dynamics in less dominant parts of our work, it is better to use a more gradual transition between elements (gradation).

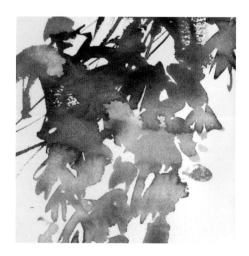

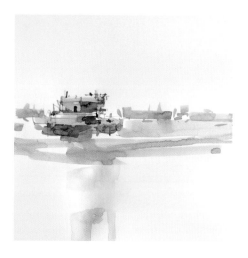

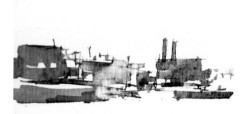

Warm and cool colours form the basis of this predominantly diagonal composition.

The dominant, unpainted section means that all one's attention is drawn to the principal theme.

Paint 'open' shapes, in which the white of the surrounding area resonates in the shape. This keeps the picture lighter and lets it breathe. The dominant blue ensures unity.

Dominance

There is no democracy in the art of painting, but a dictatorship. One tonal quality, one type of line and form will predominate in every painting. Dominance neutralises contrast and creates unity. In order to achieve this unity, we must not let all the elements dominate. Only one or two of the elements of line, tone, colour, texture, form, proportion and direction should prevail in order to create harmony.

The easiest way to incorporate dominance into a work is to echo an element. For a better understanding of unity, contrast and dominance, study the examples included in this chapter.

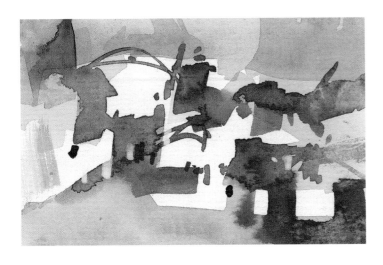

Dominant straight lines and cool colours are enough to create unity. A few curved lines and warm colours provide contrast.

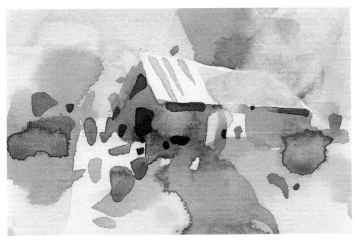

The predominant halftones and warm colours are kept in balance by light and dark accents and cool details.

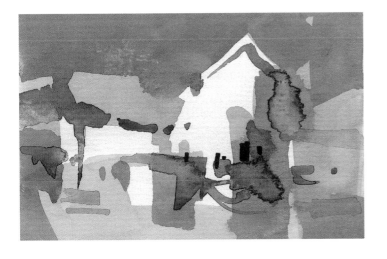

Here, the straight lines and cool colours dominate, together with halftones. Curved lines, warm colours and light/dark tones serve as contrast and add more life to the picture.

Gradation from cool to warm colour, from large to small forms, and tonal gradation.

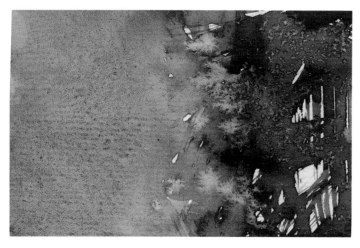

Gradual transition from a smooth to a rough texture and from light to darker tonal quality.

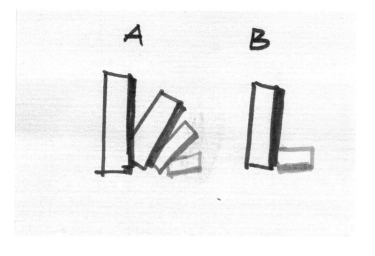

Gradation from the vertical (A) as opposed to an abrupt transition (B) by way of contrast.

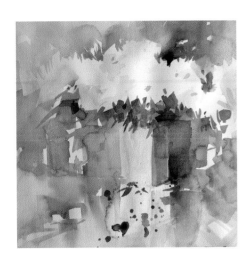

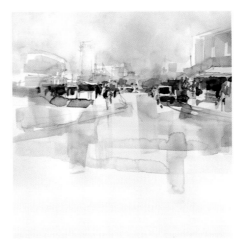

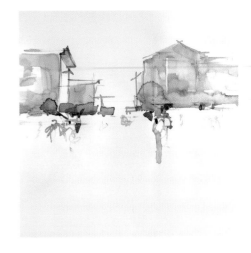

'Keep it simple' could be the motto for abstract painting. It is better to ask 'What else can I take away?' than 'What else can I add?' The gradual colour transition directs the attention to the section with the greatest contrast.

A few streaks and smudges in warm and cool colours are often enough. Gradations of tone and colour draw the attention to the central section of this impression.

An example of minimalism. Maybe too little for some but enough for me. Look at the colour gradation.

Gradation

Gradation is a progressive transition from dark to light, from cool to warm colours, smooth to rough textures, from vertical to horizontal, a change of form, proportion or direction. Gradation is a movement that brings a work to life. It is a compositional principle like that used by Ravel in his *Bolero* (gradually increasing speed). Gradation is less aggressive in visual terms than contrast and is therefore more suitable for large areas that demand less attention. Gradation is a natural phenomenon, like the gradual transition of the seasons, ebb and flow of the tides, the transition from day to night, to name but a few examples.

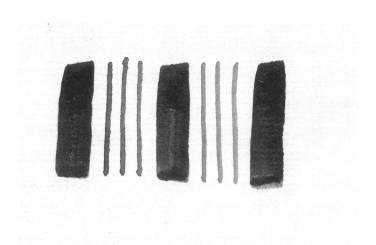

An alternating repetition of elements with the same interval and height is suitable for decorative patterns, but is boring in painting.

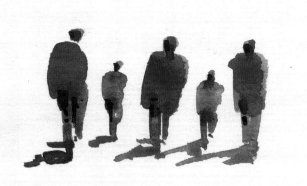

The heights here are varied but the intervals – the mutual distances – are kept the same.

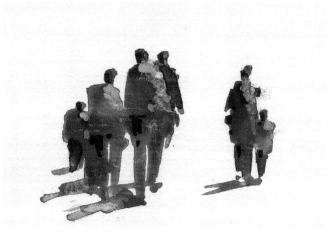

A varied repetition with alternating form and interval.

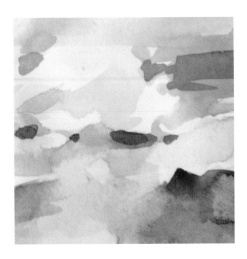
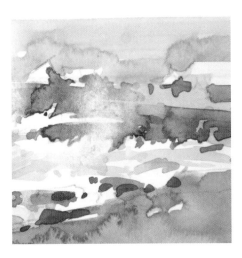
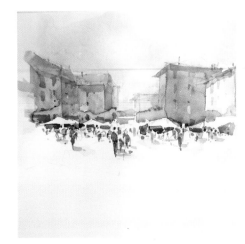

This suggestive interpretation of rocks and water could not be more simple. A varied repetition of horizontals.

Here, greater accent is placed on the nuances of colour than on tonal quality. Notice the repeated horizontal movement.

Here, again, the foreground and sky are given cursory treatment so that all your attention shifts to the principal motif. The suggested figures are repeated forms with variations.

Repetition

Repeating elements is one way of bringing unity into a work. You could say that we create echoes of line, colour, texture, form, size or direction – not precisely but with a degree of variation. A repeated colour, for example, may have a different shade; a line may vary in direction or length and a shape in size. As well as balance, harmony and gradation, varied repetition will create unity in your work. You should therefore never place an element just once but repeat it in a different place in an attenuated form.

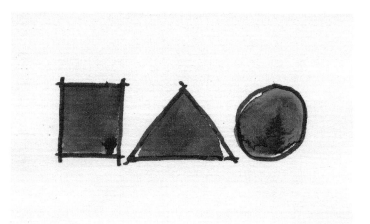

Harmony is achieved by using the same tone, colour and texture. The elements of line and form are different.

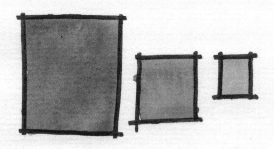

The form is the linking, harmonious factor here. The other elements differ.

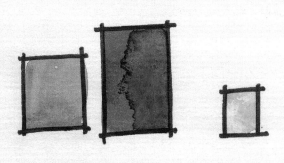

Differences in tonal quality create variation. Similar forms and colours create harmony.

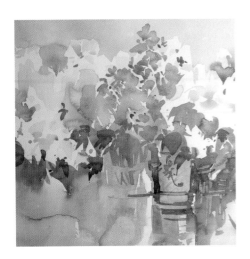

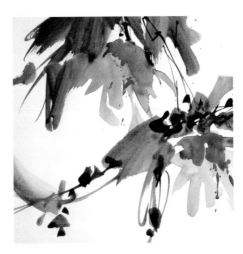

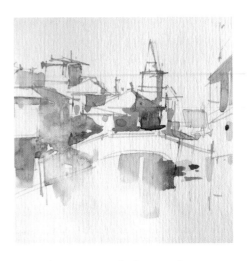

A single figurative element is all it takes to evoke the suggestion of flowers. Leave more to the viewer's imagination. Nuances of blue create harmony.

A gesture set down in calligraphic style with alternating active and restful components. Similar brushstrokes have a harmonious effect.

A rapid impression: the lines and accents are applied exclusively in and around the principal theme.

Harmony

Harmony is created when the pictorial elements show congruence. Like gradation, it lies between dullness and chaos – repetition with variation. Blue and blue-green are an example. The importance of variation as a principle of composition can be seen once again here.

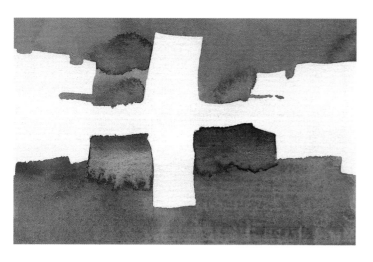

Symmetric balance has a stiff and static effect.

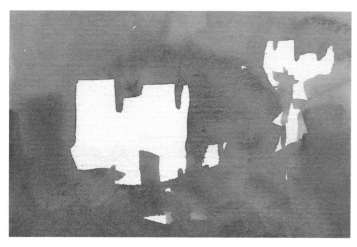

Asymmetric balance gives more playfulness and dynamism.

As far as balance is concerned, the larger the shape, the closer it should be to the centre. Keeping smaller shapes nearer to the edges maintains balance.

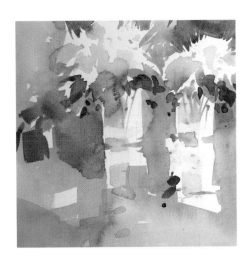

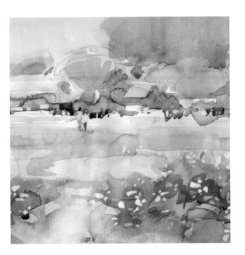

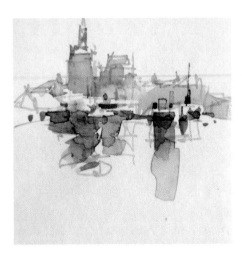

The predominant blue-green colour creates unity in this work. Notice how the dark leaf motif is anchored at the edges. This stops the picture from floating away. The small dark splashes in the lower right section serve to provide balance.

The shapes of mountains, houses and people blend into one another almost completely. By linking up shapes, the figurative elements are forced into the background. The darker section in the lower right keeps the whole picture in balance.

Warm–cool contrast creates space. Here, again, we find activity versus calm. The left-hand side is balanced by the vertical lines on the right.

Balance

Balance develops as opposing forces neutralise one another, either symmetrically or asymmetrically. In the latter case, the composition that is created is far more dynamic. Balance does not need to be horizontal by definition. A diagonal balance gives a far more lively picture.

Here the lines suggest the outline of shapes and are predominantly straight. The single curved line provides contrast.

The dominant straight, vertical lines provide unity, a single horizontal giving contrast.

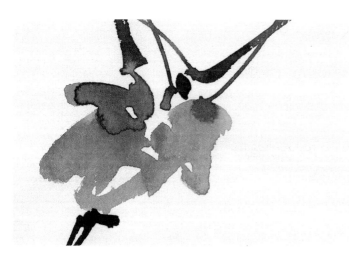

Vary the thickness, length and direction of lines. Diagonal lines bring dynamics into the picture.

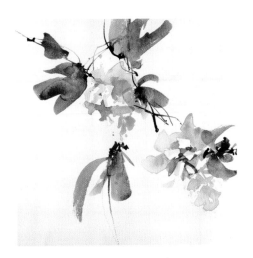

A diagonal movement brings the overall picture to life. Notice the contrast here between line and form.

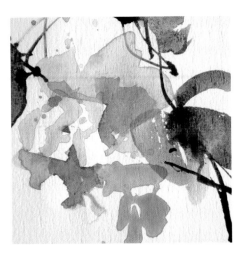

Just a few strokes of paint can result in a lovely picture. Here, we have focused in on the previous work.

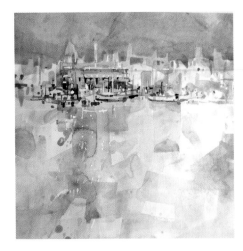

A rapid impression: the lines and accents are applied exclusively in and around the principal theme.

Line

Line suggests the contour of a shape. A line may be straight or curved but can also vary in thickness, length, direction, tone, colour or texture. The variation in direction may be horizontal, vertical or diagonal. Make sure that one type of line is dominant in your composition so as to create unity.

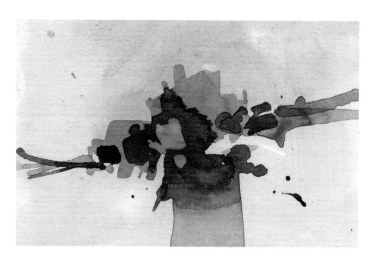

Here, the light tones predominate and provide unity.

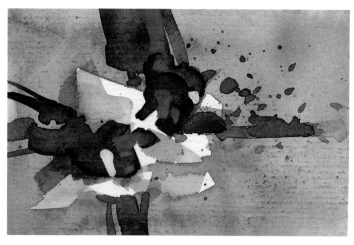

Dominant halftones with light and dark tonal values as contrast.

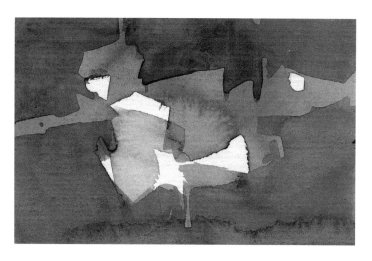

Dark tone as the basis – light tones and halftones ensure liveliness.

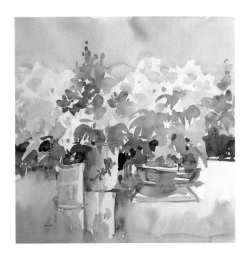

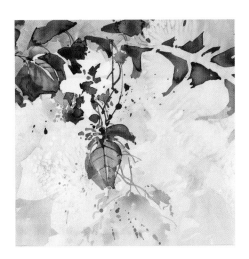

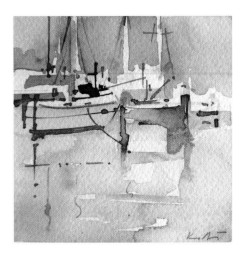

A dark tone is woven through the picture as a binding element.

Decorative and figurative elements alternate here. In the majority of the picture, the underpainting is still visible. Notice the difference in tonal quality between the top and bottom.

Contrast in line and tone forms the basis of this sketch. Try to simplify your subjects as much as possible.

Tone

Light and dark are vitally important in a painting. A painting in light tones evokes a different emotional response from one in predominantly dark tones. The tonal quality in which a subject is represented has to be appropriate: a spring landscape should not be painted in sombre, dark tones, nor a threatening situation in light tones. The seven principles also apply to tonal values, for instance one dominant tonal quality with subordinate contrasting tones. We can roughly classify our subject as follows:

1. light dominant tone with halftone and dark tone as contrast
2. dominant mid-tone and light and dark tones as contrast
3. dark dominant tone with light tone and halftone as contrast.

Many painters consider tonal quality the most important element of a picture. In order to create cohesion and variation in the work, we have to reduce the diversity of tone found in nature to light, mid- and dark tones. We can achieve this simplification by looking at reality through our eyelashes, with eyes half closed. When you do this, all details disappear and we see a cohesive whole, in which light and dark tones are clearly separated. The mid-tone performs a bridging function here.

Variation in tonal values with alternating warm and cool colours.

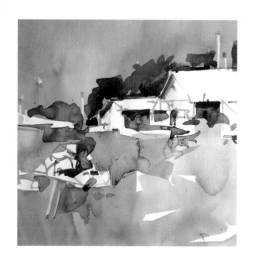

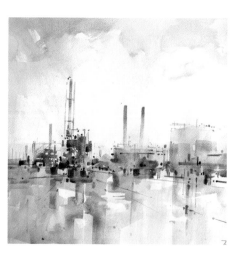

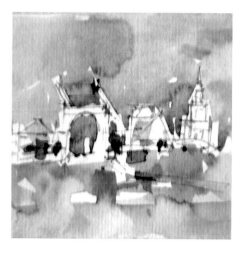

Here, the diagonal movement is emphasised. Also look closely at how the colours are echoed.

'Industry'. Just a few strokes in a restricted range of colours.

A slightly more elaborated sketch, in which the white shape pattern acts as a binding element. One colour must be allowed to dominate here.

Colour

Colour must be more than a passive imitation of reality. Colour has more to do with feeling than with seeing, so set yourself free from the 'tyranny of reality' as regards colour as well. Although an in-depth discussion of colour is not within the scope of this book, we do, of course, need to know what warm and cool colours are because we invariably have to alternate them in our work. This difference can best be shown on a colour wheel, and any discussion of colour harmonies should also be based on this. A distinction can be made between complementary and analogous colours. Complementary colours are the contrasting colours situated opposite one another on the colour wheel, while analogous colours are the harmonious colours located next to one another on the wheel. The warm colours are reds, oranges and yellows; the cool ones are blues, blue-greens and violet. In this context, any colour with blue in it is cool, so that red + a little blue = magenta, a cool red, while yellow + a little blue = green-yellow, a cool yellow. Bear in mind that warm and cool are relative terms: magenta is a cool red next to orange-red but looks warmer next to blue. The most balanced colour harmony can be achieved using a limited palette of three, or at most five, colours. Let one colour dominate and ensure that you echo colours, repeating them elsewhere in the work.

All the primary colours are present here, but the blue dominates the red and yellow. This dominance ensures unity in the work.

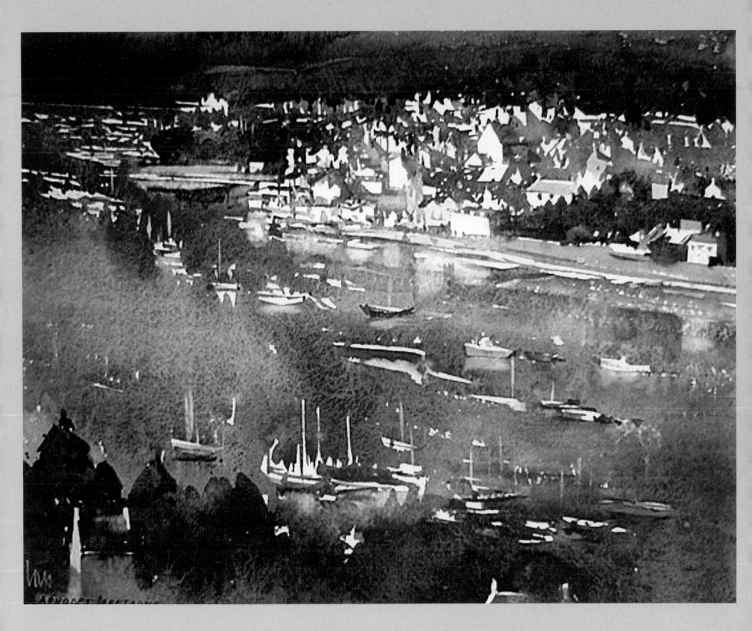

Piet Lap
Watercolour
*Variation in colour and tone brings plenty
of life into this watercolour. The dominance
of blue is a unifying factor.*

Colour harmonies

Colour and tone are the most powerful design elements for conveying emotion. In order to give you an idea of how we can use these elements, it is useful to think about colour harmony. Let us take the colour wheel as a starting point. It is divided into the primary (main) colours of red, blue and yellow, the secondary mixtures of these colours, orange (yellow + red), green (yellow + blue) and violet (red + blue), and the tertiary colours, the mixtures of primary and secondary colours. We can also use variations in the tonal quality of the colours. I have shown this for blue and orange in the colour wheel: blue with white or more water produces light blue; with grey or (the complementary colour) orange, it produces darker grey-blue. The same applies to the tonal values of orange: orange with white or water and orange with grey or blue (= brown). Complete the colour wheel for yourself with the light and dark tonal qualities. You can use a wheel like this as a handy reference while you are working. We can broadly distinguish the following three harmonies:

Complementary harmony
Complementary colours are those that lie opposite one another on the colour wheel, such as blue – orange, red – green, yellow – violet, etc. We can further vary tonal values to bring a picture to life, e.g. light blue opposite brown (= orange-grey), but do let one colour dominate in all the harmonies.

Analogous harmony
This is a series of related colours that lie next to one another on the colour wheel. These colours share a basic hue, unlike those in complementary harmony. For example, blue, blue-green and violet all have blue as a common 'parent hue'.

Complementary/analogous harmony
This is a combination of complementary and analogous harmony above. For example, blue with orange, reddish orange and yellowish orange or the variations in tonal value of these.

This has been a brief summary of a few colour applications. Do bear in mind that the most colourful painting is not necessarily the one with the most and brightest colours. Muted warm or cool colours are an ideal background against which more vivid colours contrast beautifully.

There are a few more simple tips for achieving harmony. These include painting on a coloured background or applying a thin layer of colour – a glaze – after the painting is finished and completely dry.

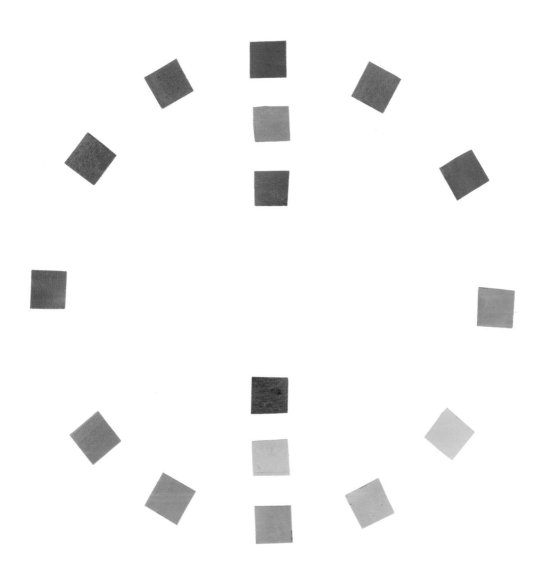

As well as colour values, tonal values can also vary. Here, blue and orange have been mixed with white and black.

Hard texture at the edges, soft texture (wet in wet) towards the inside.

Rough texture in the form, hard texture at the edges.

Soft texture both at the edges and in the shape.

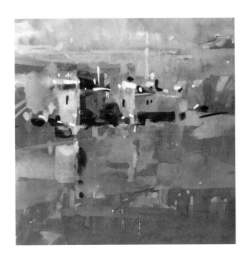

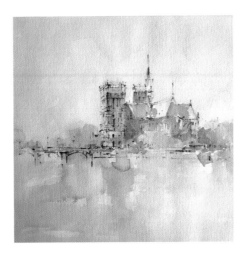

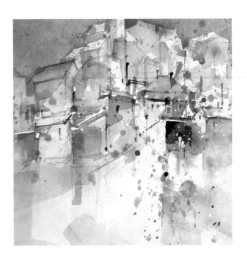

A figurative illusion is evoked on orange-tinted paper in acrylic. Keep everything simple: less is more. Notice the difference in texture created with watercolours.

If you tend more towards the figurative, you can make a drawing on an abstract background. Here, the textural difference between the delicate watercolour and the firm line is emphasised.

Here, too, the lines and details draw the eye to the focus of attention; a few spatters of gouache bring the picture to life and give it more texture.

Texture

Texture is the visual rendering of our sense of touch. When we translate the rough texture of tree bark into a painting it does not necessarily have to be in impasto with thick blobs of paint. We can also suggest the roughness with a dry brushstroke or a structured ground. Texture in a painting enriches areas of the painting that are flat and uninteresting, but too much difference in texture runs the risk of destroying the unity of the work. The surface of an object may be hard and rough or soft and smooth. Allow one texture to dominate in your work. Emphasise the most characteristic texture of an object (hard, rough or soft).

A right angle is a pretty uninteresting static shape.

A little variation at the edges brings the shape to life.

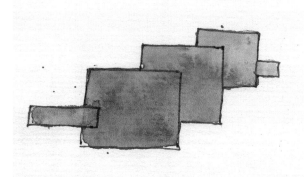

Overlapping uninteresting shapes can make the overall shape acceptable once more.

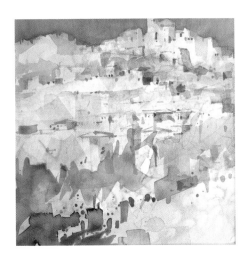 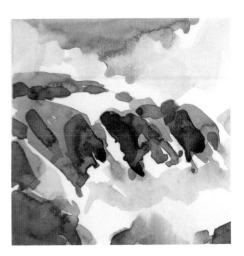 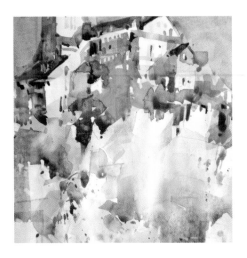

A dreamy picture, in which the composition is anchored by a zigzag movement that cuts subtly through the picture. Note the repetition of shapes.

A subject in which the tonal contrast is emphasised and a dynamic diagonal has been introduced. Look at the rhythm of similar shapes.

A suggestion of architecture is evoked at the top of this picture. The lower part is almost entirely abstract. The character of the shape is repeated here.

Form

We can distinguish between three basic types of form or shape: square, circle and equilateral triangle. These basic shapes are aesthetically not very interesting because they are too symmetrical. A shape becomes more attractive if the sides are of different lengths, one side slants or there is some variation in detail. It is important here for one type of shape to dominate in a work, and for the shapes to overlap and not be placed parallel to one another but with some variation in their direction.

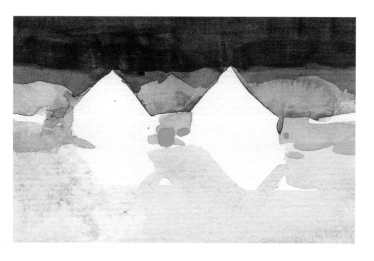

Similar shapes make for a monotonous impression.

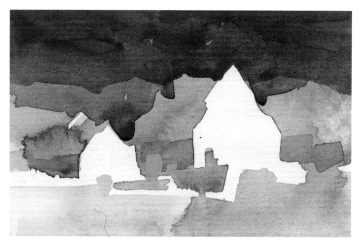

Variation in size gives the picture more tension.

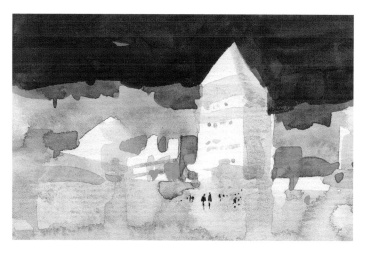

This is further amplified by the proportions of the human figures.

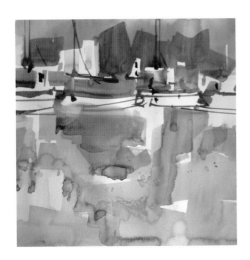

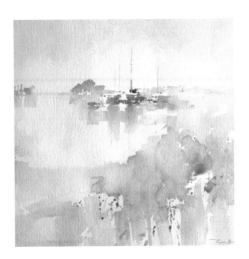

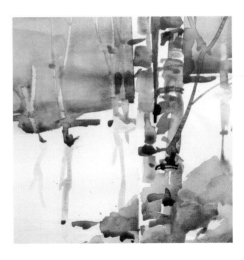

A few details and accents have been applied with pen and watercolour paint in the section to which the attention is drawn. The rest is comparatively empty.

An attempt has been made here to achieve an optimum result with minimum resources. Note the relative proportions of activity and calm.

Focusing in on an object makes the picture more decorative and abstract.

Proportion

Proportion or size can affect all the other elements of design: line, tone, colour, texture and form. Varying proportion is important for distinguishing dominant and less important components from one another and allowing them to contrast.

Variation in size has much to contribute to a composition. The design principles of dominance, variation and contrast already lead the artist in the right direction. A contrast in proportion can also contribute significantly to an impressive picture. For example, a small figure against an enormous mass of rock emphasises the power of nature.

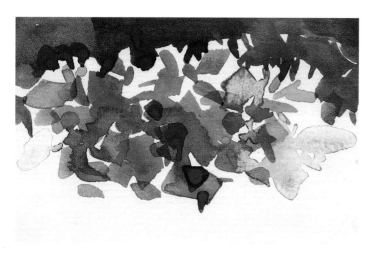

The horizontal, vertical and diagonal directions respectively are predominant in these three compositions.

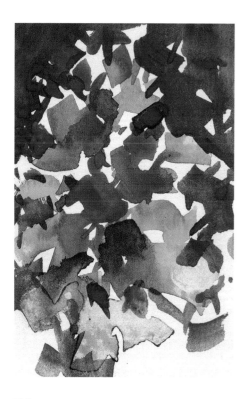

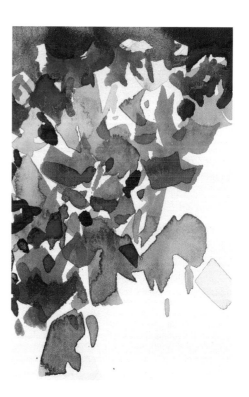

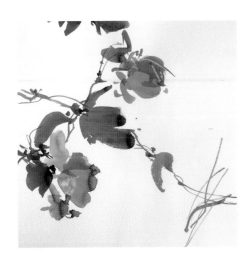

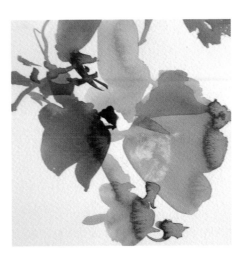

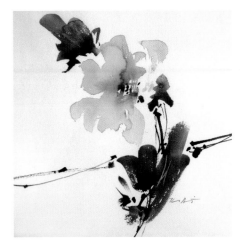

A combination of lines and surfaces increases tension; the diagonal is dominant in this work.

Focusing in on an image of this type often has a positive effect on the picture.

The curved vertical movement is offset here by the horizontal line. Always allow one movement to dominate.

Direction

There are three main directions: horizontal, vertical and diagonal. One of these directions must be dominant. The slanting diagonal line renders a work more dynamic, so you should always try to pick up one or more slanting lines in your work. The subject will usually determine the dominant direction: a forest or the interior of a church demands vertical dominance, a sea view requires a horizontal emphasis, whereas in a storm scene (figures battling against the wind), the diagonal direction will prevail. Avoid movement towards the corners of the picture; it will draw attention away from the centre of the painting.

When studying the principles and elements of composition, you will discover that many aspects are interrelated. In fact, each principle can be applied to every element. For example, tonal quality in a painting can be used by means of dominance to bring unity into the work, and by means of contrast with other tonal qualities to bring variation. The repetition of tonal qualities elsewhere in the work will create balance and harmony. Although it is possible to apply each principle to every element, this is not always necessary.

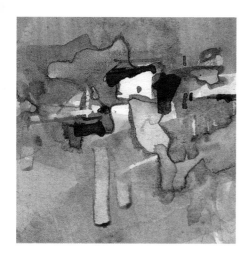

How do I combine reality and illusion?

Stylisation

Realism and the abstract have many things in common. In realism, reality is depicted as you see it, giving an illusion of reality. In abstract art, there is more stylisation by means of deforming, reducing and simplifying reality.

'An artist should never be a prisoner of himself, prisoner of style, prisoner of reputation or prisoner of success.'
Henri Matisse

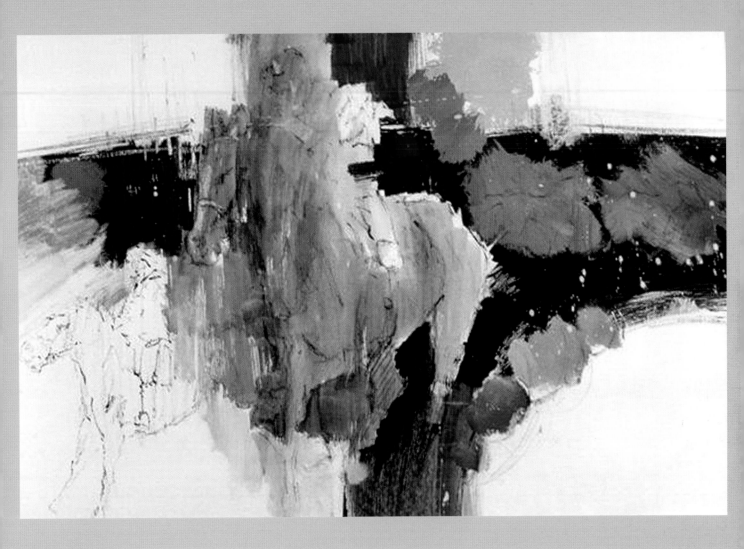

Jacques Wesselius
Acrylic
The sketchy style of pictorialisation gives movement to this subject. Notice the powerful abstract composition.

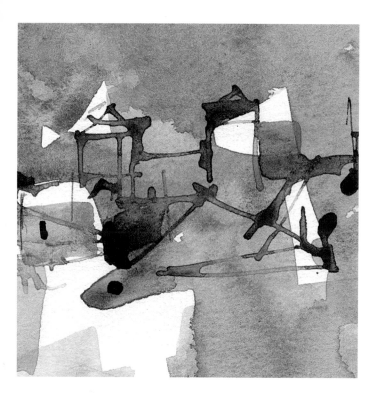

Figurative and abstract art go hand in hand here.

Both art forms use pictorial elements and principles in their expression. In abstract art, these elements and principles, such as line, tone, colour, structure, form, movement, contrast, harmony, etc., are the most important factors. In the case of realism, the picture also contains a spark of reality, but the elements and principles are just as important.

Jackson Pollock put it succinctly: 'Playing around with elements of painting may be enough for an abstract painter, but what has abstraction added to what is not there?' If you zoom in on a fragment of a figurative work, you will often find the most beautiful abstract painting, but it is, and remains, a figurative work.

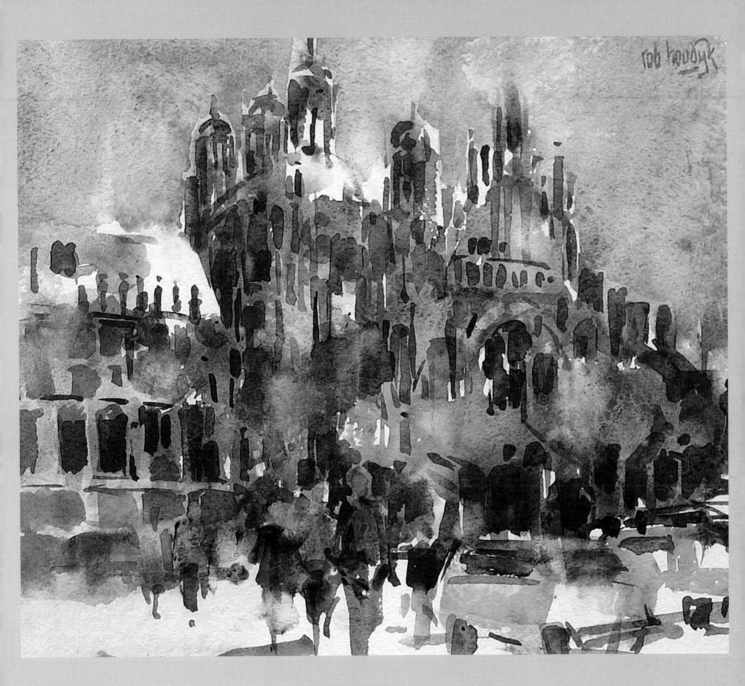

Rob Houdijk
Watercolour
Abstract elements and reality are linked here
to form an intriguing piece of art.

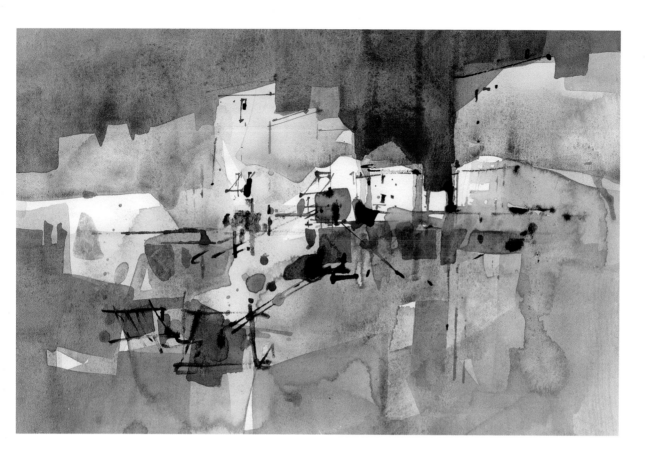

Kees van Aalst
Acrylic

Semi-figurative art

You can see that many details are often suppressed in figurative art as well. This simplified representation results in a form of 'semi-figurative art', located in the grey area between photorealism and Mondrian – grey, but very colourful nonetheless.

'We all know that art is not truth. Art is a lie that makes us realise the truth,
at least the truth that is given to us to understand.'
Pablo Picasso

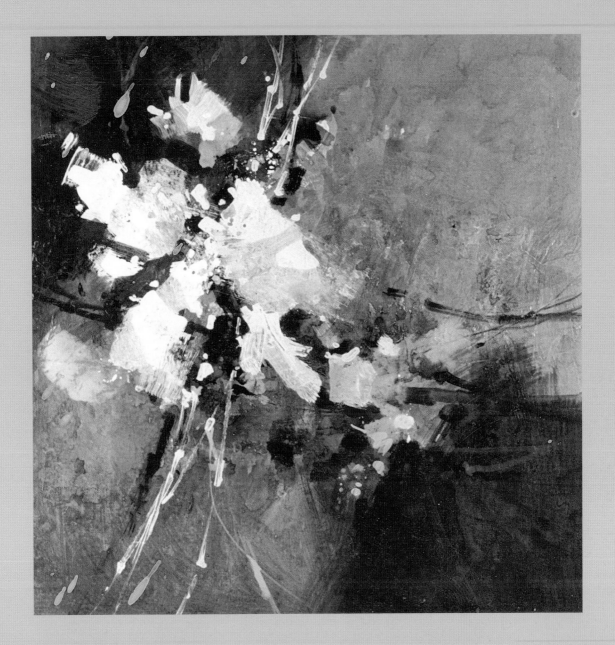

Kees van Aalst
Acrylic

Xavier Swolfs
Watercolour, detail

You will find good and bad painters in all fields of art, but an artist might think he or she can paint abstracts because they are unable to paint anything else. He or she takes refuge in the streaks and smudges that result from their lack of technical skill. In other arts, such as music and literature, you have to have some mastery of the necessary techniques; it is not for nothing that you are called a craftsman.

I am a fan of what is known as semi-figurative art, in which reality is manipulated as much or as little as you wish. It is a mixture of illustrative and decorative elements; of three-dimensional illusion created on a flat surface composed of paint and canvas – the basic elements of the art of painting.

*'Believe only what an artist does, rather than
what he says about his work.'*
David Hockney

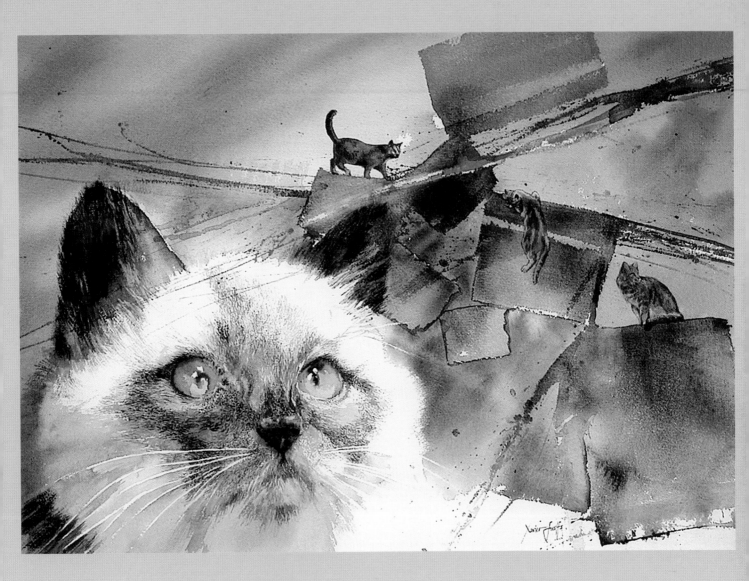

Xavier Swolfs
Watercolour
Here, the illustrative and abstract elements
have been skilfully combined.

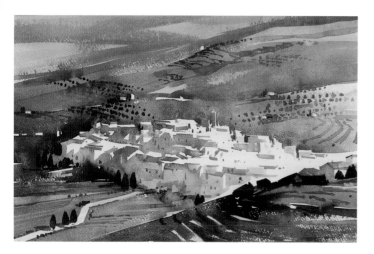

Piet Lap
Watercolour
*Here, the artist has subordinated the details
to the overall form and has raised the picture
above being simply an illustration.*

Illusion

Every painter handles the combination of paint and canvas differently. One will leave large areas unfinished, so that the basic framework remains visible. Another will even leave parts of the paper or canvas unpainted. A third, while painting everything, will distort, simplify and condense the subject. But what all these semi-figurative artists have in common is the evocation of an illusion of reality, in which the painting process itself is important. It remains, ultimately, however, paint on paper. So just let the brushstroke, the actual artistic element, be visible. Emphasise it, even. Reality is being translated and reshaped here with 'a bit of paint, a bit of you', to use painting vocabulary.

I have tried to convey here that the mental approach to art is more important than the technical. In order to emphasise this I have repeated myself a great deal, but by looking at the same material from different angles or in a different context I hope to gradually make it clearer for you to understand.

'Great art lives on scanty means.'
le Corbusier

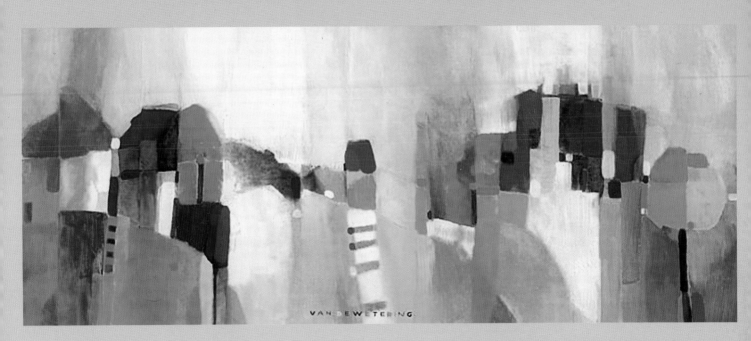

Kees van de Wetering
Watercolour
*An abstract pattern of blocks and colours
forms the framework of this painting based
on reality.*

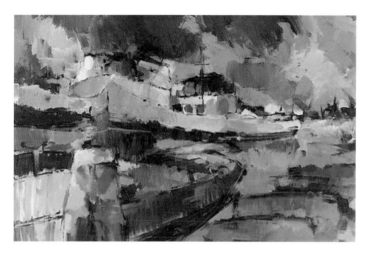

Jacques Wesselius
Acrylic
This suggestion of a harbour has a strong abstract basis, combining the shapes in a harmonious manner.

Pretty picture or good painting?

A painting based on reality can never be actual reality no matter how hard you try. It will always remain a picture on a flat surface, an illusion. And why not reinforce this illusion a little by suggestion rather than by depiction? At the start of his or her career, an artist is often preoccupied with the precise depiction of reality. Later, you learn that not depicting parts of a scene, or depicting them only vaguely, lends greater strength to the work as a whole.

Have you ever felt that your palette looks more beautiful than the picture on which you are working – amazing colour combinations spontaneously seeking a path on a virgin background? Such a sight always arouses in me the feeling I experience when I am listening to beautiful music – beauty without the least connection to reality. This purely abstract manner of painting, based merely on form, tone, colour and texture, will perhaps not satisfy many people. But what is to stop us from choosing a middle ground between figurative and abstract art?

'I never saw an ugly thing in my life: for let the form of an object be what it may – light, shade and perspective will always make it beautiful.'
John Constable

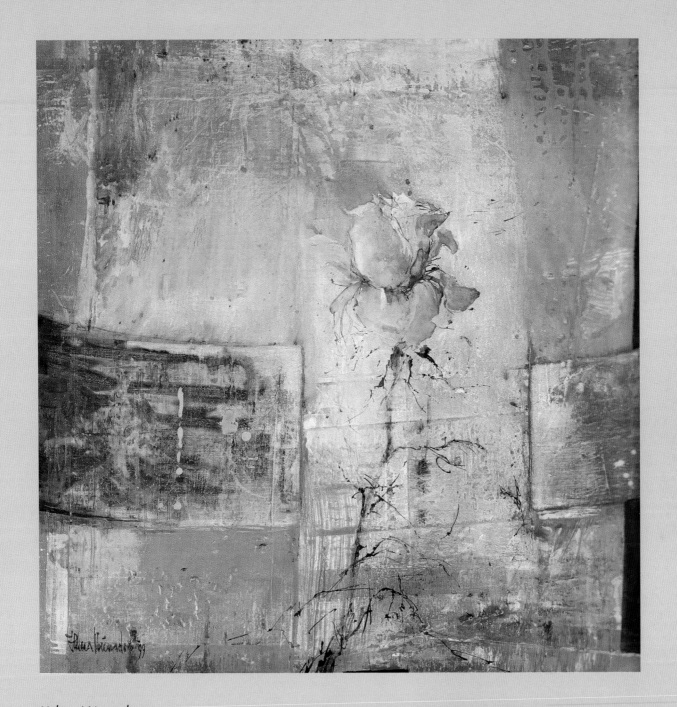

Heleen Vriesendorp
Acrylic
*A mixture of realistic and abstract elements
forms a perfect combination for this
intriguing piece of art.*

Technique or art?

You have no doubt learned how you should paint landscapes, flowers, still life and so on. But how often have you looked deeply into creating cohesion in a painting, which is what turns technique into art? A common mistake is to try to depict far too much in a painting. An excess of unconnected detail is the surest way of causing your work to fail. So keep it simple. Teachers are often far too concerned with teaching you how to paint objects without paying attention to simple cohesion and straightforward composition. A good teacher will command respect, not by discouragement through making their art seem unattainable, but by a reductive, simple approach so that students will think 'I can do that too.'

A good painting requires balance, harmony and repetition, in short cohesion. But it also needs variation. Creating good paintings is a skill that can be taught. As I said earlier, you may be overwhelmed by the multitude of impressions a scene can make if you are painting from nature. To lessen this chaos, you have to ask yourself why you want to paint that particular subject; what is the essence that has captivated you and how can you capture it? Try to evoke an interesting image with the minimum of lines and surfaces. An ideal aid to doing this is pressure of time: little sketches taking five to ten minutes, no longer. Start by planning the large shapes without getting lost in the details. Leave pencil lines visible – they reinforce the loose, lively and spontaneous approach. Finally, add a few suggested details, and your painting is finished! Above all, avoid over-elaborating the details, which will destroy the sense of spontaneity. Although this approach will feel incomplete to many people, it is the ideal basis for learning how to work more loosely.

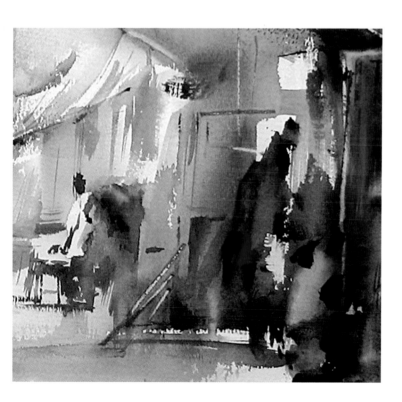

Cao Bei-An
Watercolour, detail

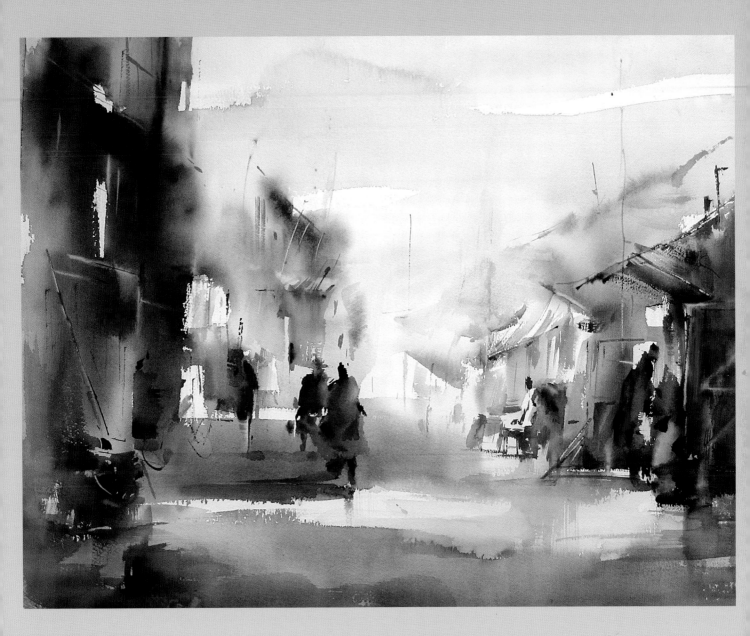

Cao Bei-An
Watercolour
A few fluid strokes of colour with a minimal amount of detail results in a lively picture.

Kees van de Wetering
Strong graphic elements give this
composition an unprecedented strength.

A simple, balanced pattern of tonal quality is almost a guarantee of success in your work. If you can express yourself in a few tonal values, you hold the key to good painting. To start with, try planning a painting in just four tones: one light, two mid-tones and one dark tone. In order to reduce your subject to this pattern of tonal qualities, look through half-shut eyes so that any nuances are lost. First, make small sketches using a soft, wide carpenter's pencil. This will avoid the temptation to draw surplus details, and you will achieve the maximum effect with minimum effort. Information is reduced to bite-sized chunks. You can see that in doing this, you will have to manipulate reality to some extent – call it a white lie if you will, but better a beautiful lie than a dull reality. So do not sketch what is there, but what should be there. Better a good painting than a precise likeness. If you produce a good tonal sketch, the work is already half done.

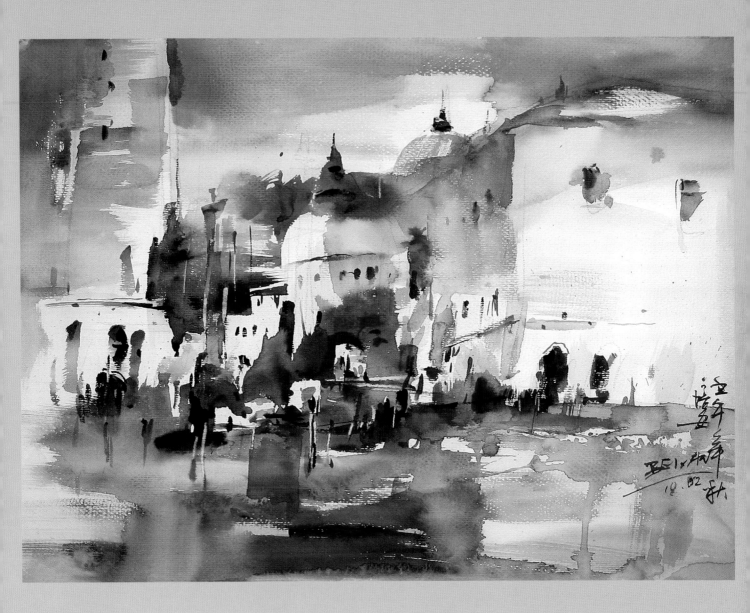

Cao Bei-An
Watercolour
The artist has skilfully managed colour and
tone to achieve cohesion.

Sketching

Many painters have already failed before their brush even touches the paper because they have not done the preparatory mental work or a tonal sketch. Some regard this as wasted time, but in my view everyone should spend time on this initial stage. In fact, a tonal sketch has some additional advantages. Light and shadow change over the course of the day, whereas in sketches the pattern of light and dark is 'frozen'. Also, making a sketch familiarises you with the subject and provides an ideal opportunity for making your work an abstract one, because in the sketch you will already have adapted reality to some degree.

How do painters make room for interpretation? Some start from a very detailed basic concept and, while working, blur this slightly, making it more like an abstract painting. The painting is then recognisable as simply paint on paper or canvas and not as a representation of reality. Others start from disorder, applying paint in an apparently chaotic manner and gradually creating an illusion of reality from that. The viewer gains an impression of the subject, which he or she builds on using their imagination.

The artist is therefore deliberately aiming to leave the work incomplete. This is not a question of mental or physical laziness; on the contrary, what is at play here is a well-considered psychological framework; a technique that is applied with dedication by both artist and viewer. The artist leaves the viewer guessing, and the viewer interprets the picture and makes the subject complete. In this way, the painter liberates him- or herself from the tyranny of reality and suggests more than he or she depicts.

'Perfection is achieved not when there is nothing more to add,
but when there is nothing left to take away.'
Antoine de Saint-Exupery

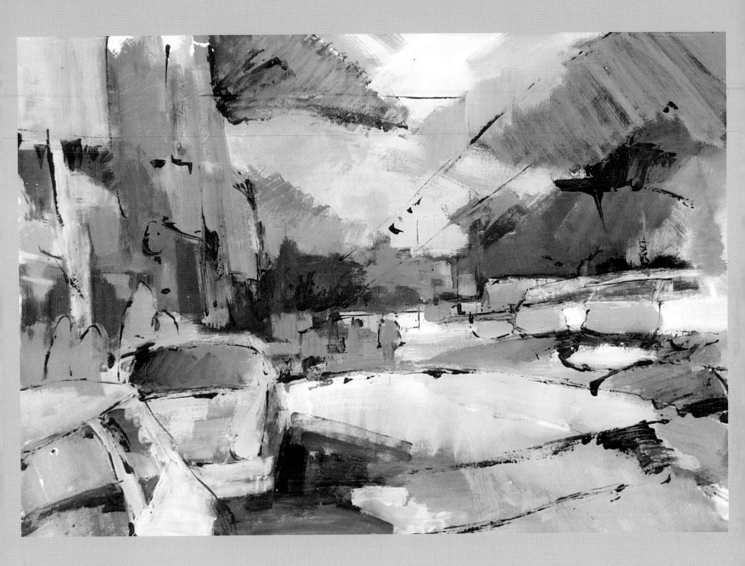

Jacques Wesselius
Acrylic
*A painting in which unity has been
achieved with colour, tone and lines.*

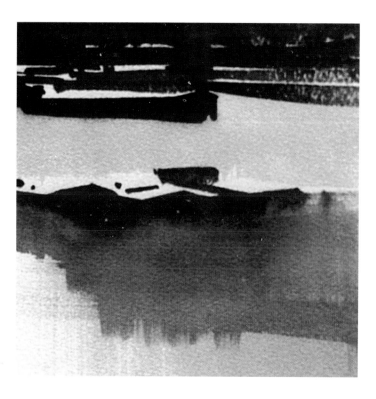

Piet Lap
Watercolour, detail

Relaxing after working hard has a healing effect on body and soul. But, after a while, relaxation becomes boring and there is a renewed need for work, for activity. It is the same with a painting. Areas with a lot of activity have to be alternated with calm areas, just as in music you have fast and tranquil passages. This progressive change is not always apparent in the subject itself. We therefore have to bend reality a little to create it. We have to guide the composition by adding something here, or leaving something out or changing something there.

For example, we may wish to draw attention to a particular part of an otherwise busy and detailed subject. The spotlight will therefore be on a small area, and the attention of the viewer will not be diluted. But such a painting, which may seem almost incomplete, does impose specific requirements of technique if it wants to make an impact. In short, how do we start, how do we direct the attention and, perhaps most importantly, when do we stop?

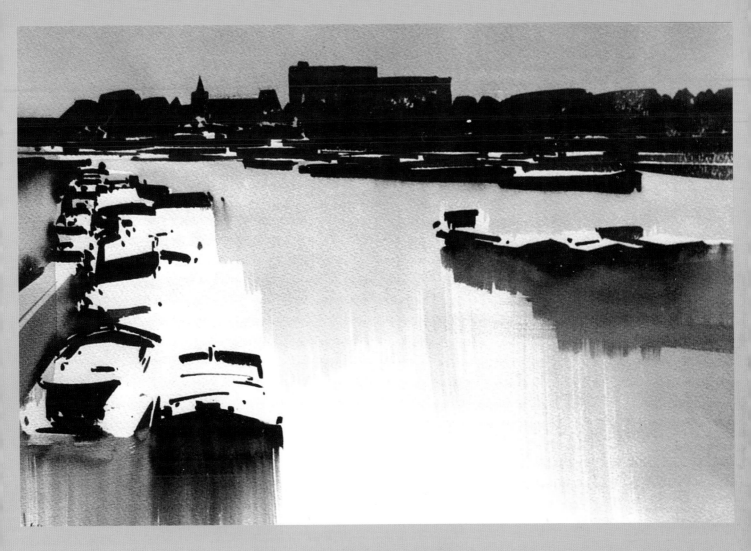

Piet Lap
Watercolour
*A strong tonal contrast gives this
watercolour a powerful abstract quality.*

I have a few suggestions that may help you work in a more structured way. Do not make your main theme too large in the picture; leave sufficient space for suggestion. Give the main theme a powerful, interesting shape. The closer you approach the edges of the paper, the less detail you should include; focus on the central portion. This central area should be off-centre so as to create a more dynamic balance. Restrict details, do not paint for too long, and stop in good time. The end result should provide a pleasant contrast between the finished and unfinished sections.

Character

A painting must have a character that is more than simply the representation of the subject; the subject is less important than the overall idea and its presentation. An abstract basis is an ideal starting point for a suggestion of figurative elements. We can often preserve a large portion of this abstract basis in our finished work.

Rob Houdijk
Watercolour, detail

'Painting is not depiction, writing is not description.'
George Braque

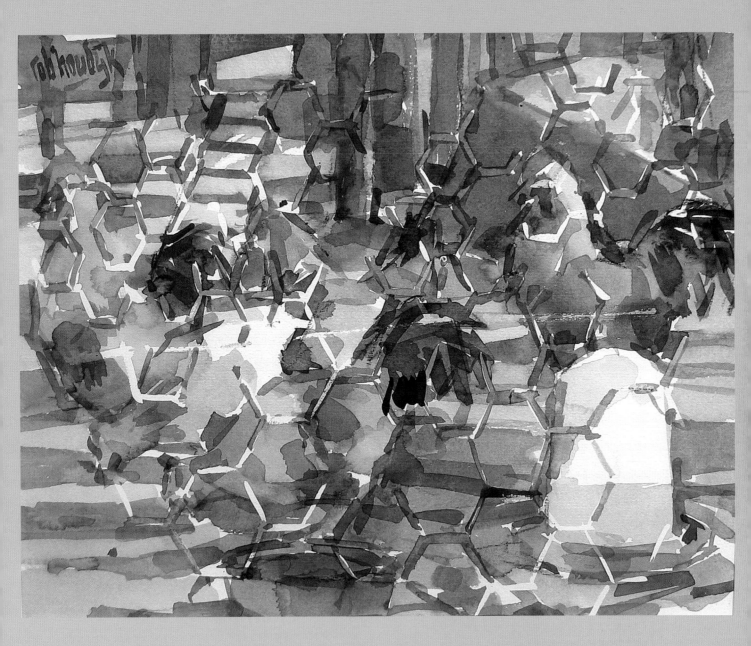

Rob Houdijk
Watercolour
*The artist has achieved an abstract
unity with an unusual element, namely
chicken wire.*

Often, only a very limited part of your painting will require activity. If you restrict detail to the main focus of the composition, you will strengthen the contrast and hence the tension of the work. Again, activity should never be extended right to the edges or placed exactly in the centre. The eye of the viewer would, in that case, be drawn to areas that are not the main focus of the work.

There are countless ways of creating a good painting, but there is one certain way of creating a bad one: depicting precisely what you see. This is because you see too much. Reality provides us with a superfluity of information, which we have to deal with selectively. We have to make choices. The great breakthrough in painting comes when you rise above what your eye can see. At that point you will realise what must be there instead of what is there.

Heleen Vriesendorp
Watercolour, detail

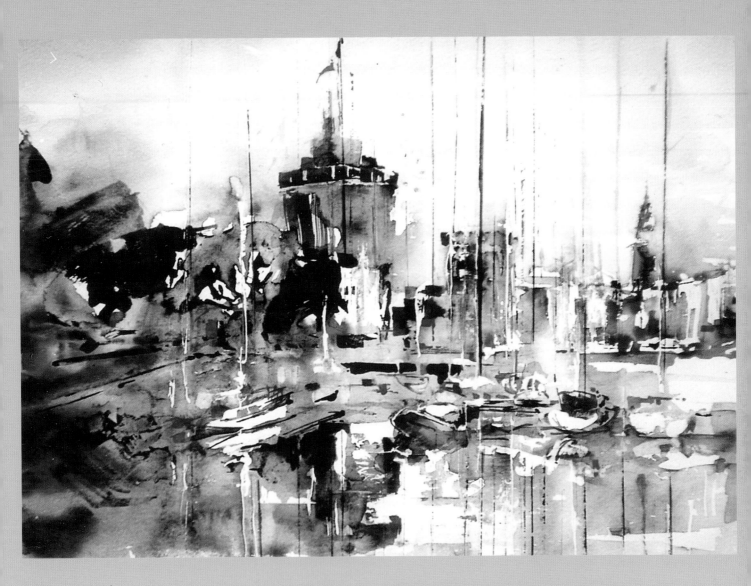

Heleen Vriesendorp
Watercolour
*The subject is not depicted here as
a number of separate items but as a
coherent pattern of form.*

Many artists, when just starting out, try to say too much at once. Limit yourself to one main motif and subordinate everything else to this. Keep it simple. Restrict yourself to large shapes with a single suggestive detail and you will see that your work improves considerably.

A painting is a composition of shapes and colours, not an imitation of objects. In order to achieve an attractive work of art you are not so much painting what is there but what should be there. One way of doing this is to start with large shapes. Always use as wide a brush as possible for this, suited to the size of the paper or canvas. Vary the surface in terms of tone, colour, form and direction. Only when the result gives you a satisfactory pattern should you move on to the more actively detailed accents. Try to work in a controlled way in this detailing stage.

Kees van de Wetering
Watercolour detail

*'Putting a title under a painting is to prop up the art of painting
with literature. A painting needs no crutches.'*
Roger Bissière

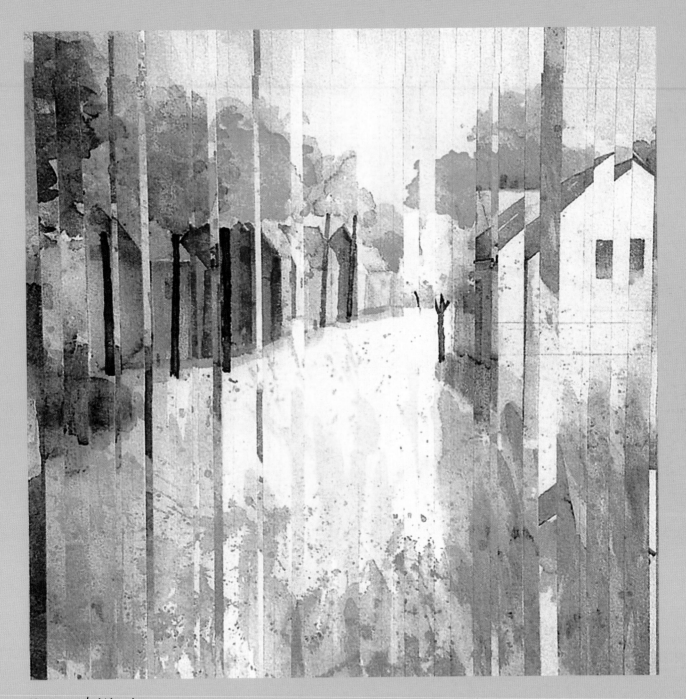

Kees van de Wetering
Watercolour
*Fragmentation with vertical stripes
gives the picture an attractive
decorative character.*

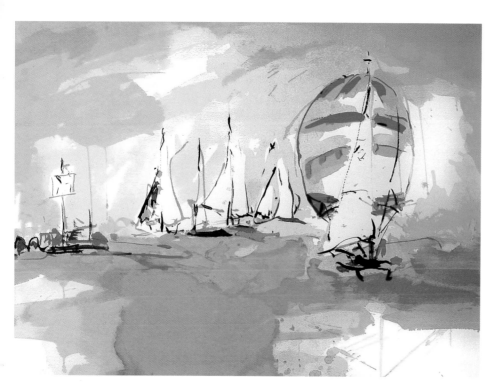

Ingrid Dingjan
Watercolour
The artist has avoided 'realistic' colours here so that an abstract picture is created.

Starting from an intuitive, spontaneously created concept in a harmonious colour palette, you then give your work a push towards reality. Limit yourself to a few principal shapes at this stage. These will give the end result more power and vitality. If you want to give a subject like this even more strength, build a powerful tonal contrast into and around it. The result will be a semi-abstract work that will give you far greater satisfaction than the stereotypical, pretty picture that you might previously have been trying to paint.

'I don't think I handle the notes much differently from other pianists. But the pauses between the notes – ah, there is where the artistry lies.'
Artur Schnabel

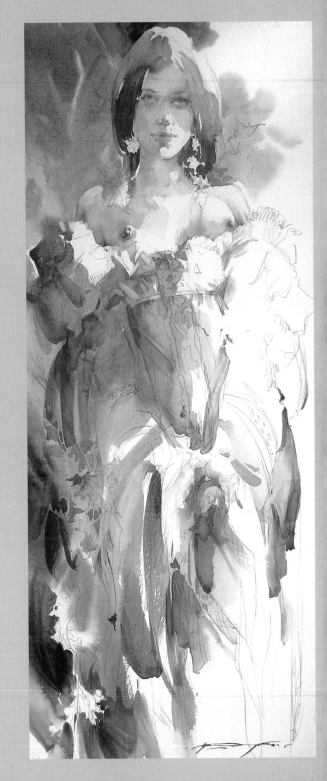

Slawa Prischedko
Watercolour
*Realism tinged with suggestive
illusion gives this watercolour a
fairytale-like atmosphere.*

How do I do that?

The wood and the trees

You have no doubt driven up a street with a plethora of traffic signs at the entrance that would utterly confuse any normal person. You are unable to take in all of the prohibition signs without endangering the other traffic. Just as you reach the end of the street you are informed by a policeman that you should not have turned into it in the first place. Something similar happens to painters who enter the artistic traffic and are confronted with an enormous set of rules for taking their work to a higher level. Rules that also often appear to contradict one another, such as harmony and contrast, repetition and variation. How is a painter to make sense of it all?

I have nothing against guidelines for improving paintings – on the contrary, but it does very little for the spontaneity of your work if you have to take too many factors into account. Do not accept advice and rules without thinking about them – the 'why' behind given guidelines is extremely important. There are already too many dogmas in the world that are followed unthinkingly.

Look at a painting you like and try to understand the thought processes of the painter. Look over his or her shoulder, so to speak, and see how their thoughts have been realised in the picture. You will discover that rules that are too hard and rigid have a disastrous effect on spontaneity. Masterpieces have been created by artists who care nothing for the rules. So look at everything as being relative, and see the rules more as a compass to keep you on course rather than having to be obeyed absolutely.

I am a great champion of simplicity in representation and of the art of omission, and the same principles can be applied to the rules, which I would rather call guidelines and starting points.

The principles described so far are, in fact, based on natural laws. What do we see around us? We see that everything changes but then always returns. Seasons, the ebb and flow of the tide, a rhythm derived from opposing forces that need one another for completeness. Forces of unity and diversity. If we apply these essential basic forces – cohesion and variation, connection and change – in our work, we make the rules easier to understand. Repetition, unity, balance, harmony and dominance all come under the umbrella of cohesion. Contrast, gradation and alternation can be grouped under the concept of variation. Both are equally important and mutually complementary. Absolute unity is dull, absolute contrasts are chaotic. So look for balance between the two forces. Always ask yourself: does this work contain enough variety in terms of tone, colour, texture and so forth and, finally, does it hold together adequately?

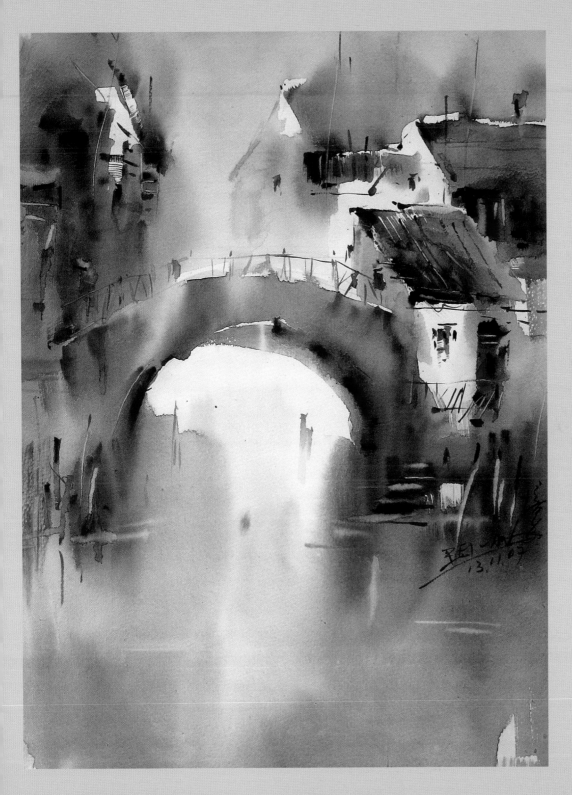

Cao Bei-An
Watercolour
The simple use of overlapping colours and shapes creates unity.

Abstract painting

A painting is a picture about something, not a picture of something. Therefore you need to interpret your subject, not imitate it. To do this, you need to simplify the information. Eliminate excessive detail that does not reinforce the character of the subject. Select only those elements that define the essence of the information (i.e. characterise the subject) and describe them in a few key words.

Let us say we are painting boats in a harbour. First, define the whole in abstract terms, such as contrasting horizontals and verticals in a warm, dark, tonal quality, and apply these characteristics to the surface of the picture with paint. If the result then accidentally resembles boats in a harbour this is a bonus but not essential at this stage. As your painting progresses, eliminate every line, tone, colour, texture, form, size or direction that negates the essence of the subject. This is the basis of abstract painting: to emphasise the essence, and in doing so, to express your own ideas and feelings about the subject and attempt to convey them in a logical manner. Look for symbols that express the character of the subject – art is communication. Select a few essential elements from a complex subject and render them in paint. The result is a reality suggested in tone, colour and texture. This is where the principles of pictorial composition come into play. The dominance of each element with alternation and contrast ensures a varied unity. Once again: limit the detail. Abstract painting is a type of visual shorthand – more suggestion than depiction. A composition like this, based on the pictorial elements listed above, is the essence of a work of art.

In order to guarantee a solid basic structure to your painting, I would advise you to always make a few preliminary sketches in which you can try out some variations on the theme. This will allow you to familiarise yourself with the subject and prevent compositional disappointments in the later, definitive work. In the preliminary sketches you should describe your subject in a few key words (angular/vertical dominance – warm colours) and then tell your story on paper or canvas in a simple pattern of tonal values. The painting is more important, in this context, than an accurate likeness. Do not worry about leaving aspects of the painting open to guesswork. Suggestion is an ideal instrument for stimulating the viewer's creativity and this makes the painting even more interesting. First paint the large shapes, starting with the whole then breaking it down into parts. If too many details are added too quickly, the concept as a whole – the narrative – risks being submerged.

Express yourself clearly, using a limited palette, with tone, form, colour and texture. A limited pattern of tonal values is very important here. Position the greatest tonal contrast in and around the focal point of the painting. Details and accents are also positioned here. In order to bring unity into the work, it is advisable to paint half to three-quarters of it in mid-tones as the dominant value. The light and dark tones then provide the necessary contrast. These light and dark tones should also be of different dimensions. So we have dominance here too, albeit secondary dominance. A word about white areas. These are often the most attractive parts of the work. White has considerable visual strength, particularly when placed next to dark tones. Do not put a white section at the edge of the picture surface, because it will draw attention away from the centre of the painting. Instead, place whites in and around the focus of attention and vary their form and size. Do not scatter the whites over your picture randomly but relate them to one another, like stepping stones in your composition. You can even put them at the focal point, where you have placed your main subject. If you have been fairly reserved in other areas, sometimes down to just a whisper, this is where you can allow yourself to be a little louder, to set up major contrasts, more vivid colours or more detail. This variation between loud and quiet sections makes your work more exciting and attractive.

Initially it is quite difficult to remember to apply all these guidelines, but it will gradually become automatic. You can develop your skills more quickly by taking a course or attending a workshop, where you will see all the principles put into practice and they will be easier to remember.

In many places in this book I argue for a synthesis, an amalgamation of the technical, craftsman-like approach and the spiritual/intuitive approach. The former is orderly and organised, the latter more poetic. It is in this latter aspect that personal input predominates, resulting in the development of your own style. But aside from this, having one's own style says nothing about the quality of the art – both a shoddy worker and a genius can develop their own styles.

A degree of open-mindedness is probably desirable in developing a unique style. A method of working that is too modest and avoids risks often lays the basis for boring, uninspired work. You may be a virtuoso interpreter of reality in the technical sense but if you are not able to express the underlying essential abstract rhythms and forms you will produce uninteresting work. Become, therefore, a master of the principles of making pictures in order to attain a higher artistic level. Even Mozart based his music on the same principles that are in fact found in every art form.

Practical application of the principles and elements of painting

In this chapter I have illustrated the pictorial elements and principles in stages, in a series of compositional sketches. These sketches have been made specifically for this book and should not be regarded as finished artworks. Their purpose is purely educational. In addition to the elements and principles already listed, I also use some personal rules of thumb. For instance, I have as little activity as possible at the edges of my picture surface, and I avoid positioning the main subject too centrally in a picture (as a rule for students I use a third of the picture surface). My personal preference is for a cohesive subject based on halftones with light and dark elements as contrast, particularly at the focal point. But, see for yourself.

Kees van Aalst
Watercolour

107

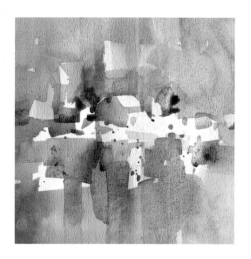

A blue-green base for a composition that evokes an illusion of architecture.

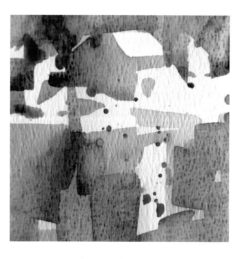

Focusing in enlarges the shapes and makes the whole picture more powerful.

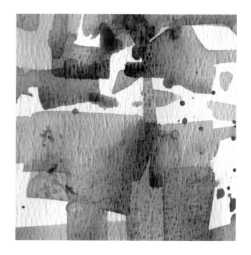

Shifting the focus of attention reveals a different picture again.

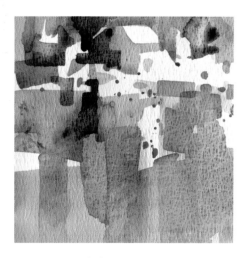

Experiment with the picture to try and develop your sense of composition.

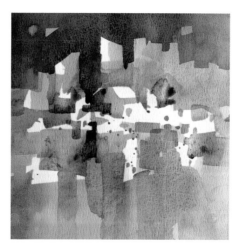

Here is the whole picture once again, with a few dark tones added.

Repetition

Repetition of similar elements, such as form and colour, creates unity in the work.

TIP:
Two L-shaped pieces of card are an ideal tool for judging your composition and doing any necessary cropping of your work.

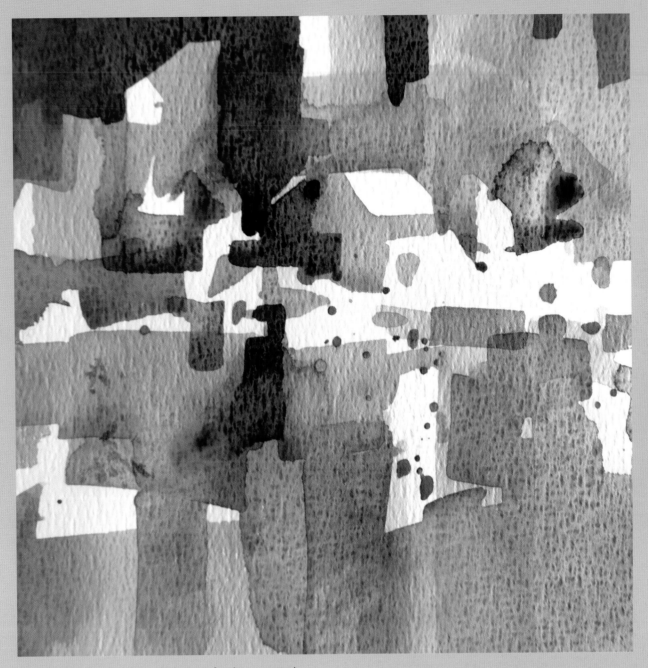

A crop as the end result. A preference for this approach
is a matter of taste.

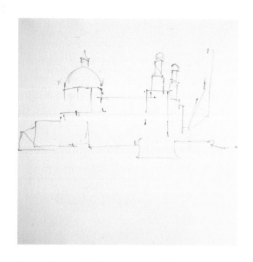

A quick pencil drawing provides an adequate structure at the planning stage.

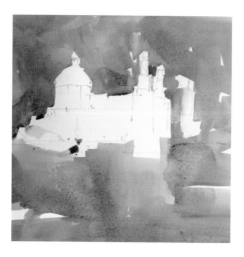

Indicate the atmosphere with a varied colour palette. Leave the main subject blank.

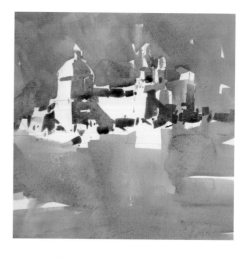

Suggest form with halftones in the main subject.

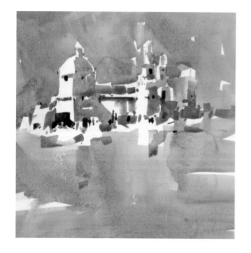

A few darker details provide greater vitality.

Colour

Release yourself from the tyranny of the realistic colour.

TIP:
Have a go at deviating from the actual colours of the subject. Paint what you feel, not what you see. By doing this you will increase the abstract quality of your work.

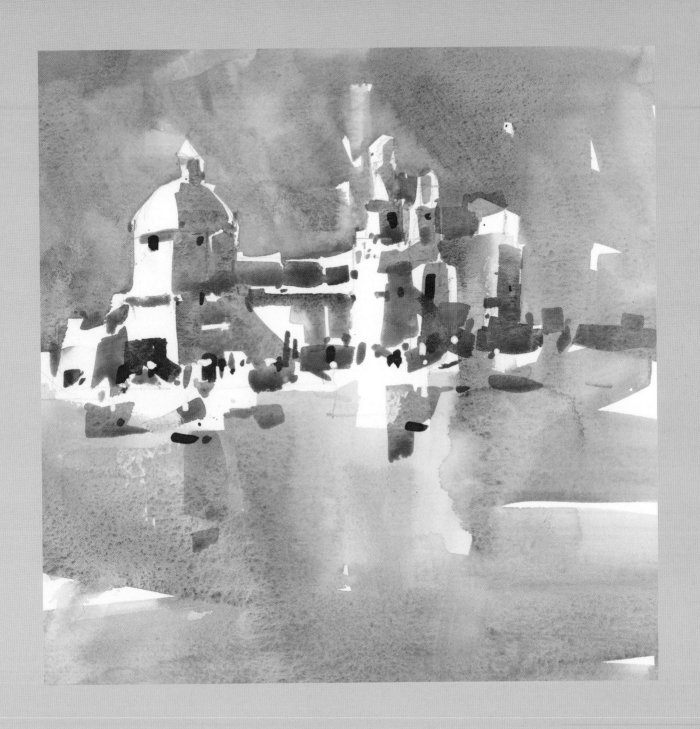

In this final stage, a few minor accents have been
added to complete the work.

A dynamic underpainting forms the basis for your composition.

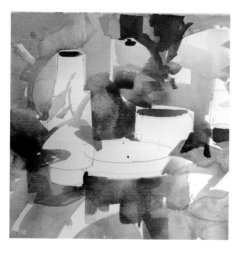

Add some colour and tone and use them to suggest a subject.

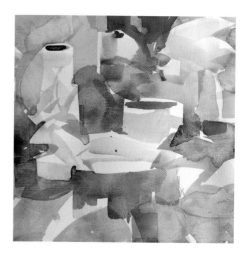

Give the large white patches some tone but preserve the unity.

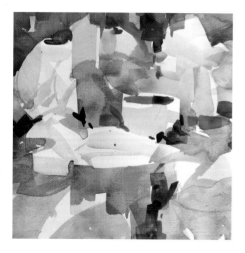

Wrap up the composition at the top and sides with a darker tonal value.

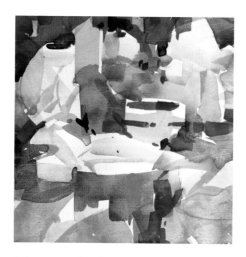

A few more details are applied with a rigger brush.

Tone

Tone is an essential pictorial element.

TIP:

Do not put objects into your picture in a random fashion but link them to each other by using the same tonal quality, and allow shapes to bleed so that they overlap and form groups.

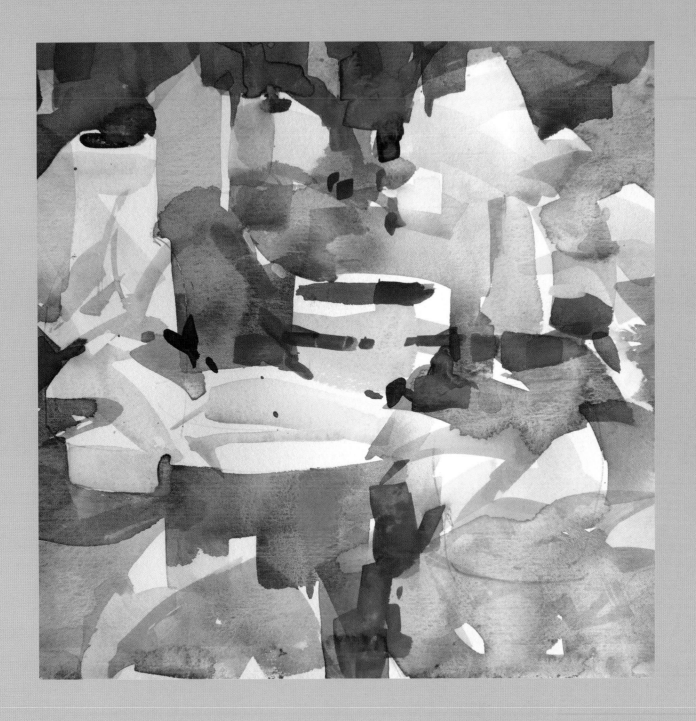

Even a small change in the window
mount will affect the picture.

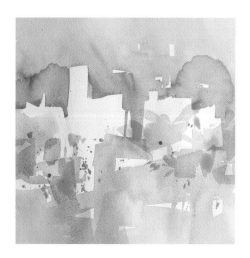

Familiar base: flat brush, limited colour palette, a white shape left untouched.

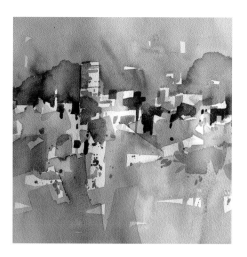

The tonal values in and around the white areas are made stronger so that more attention is drawn to this section.

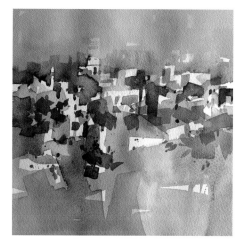

I felt that the horizontal bias in the previous stage was emphasised too much. I applied some vertical dark tones and softened the upper part with a grey-blue coat in gouache (see tip).

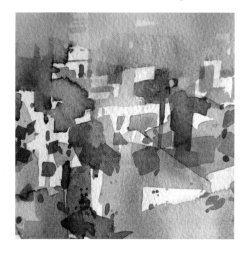

I focus in again on the whole picture using my L-shaped card.

Form

Interesting shapes have a degree of irregularity (pure squares, circles and equilateral triangles are the least attractive shapes).

TIP:
Instead of washing out watercolour paint, we can apply a coat of gouache (white + a watercolour).
This is comparable to painting out in acrylic.

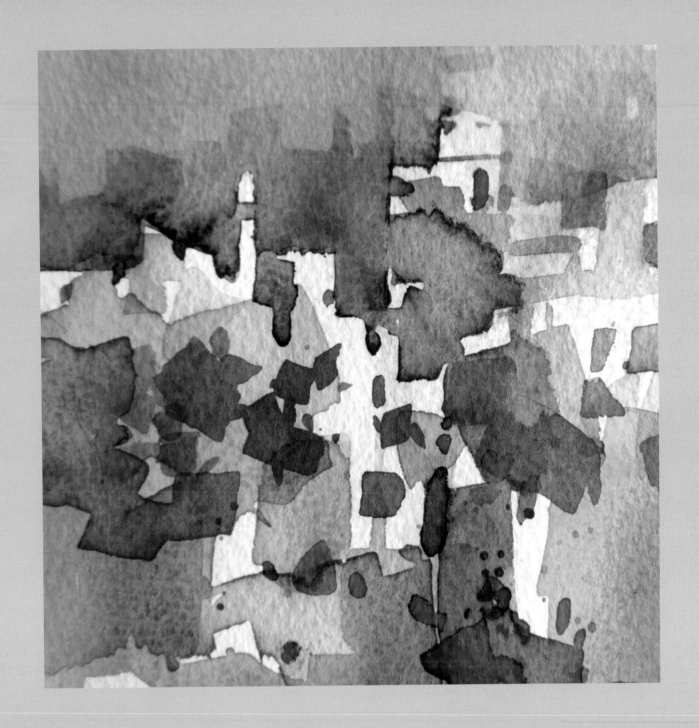

In the end I decided to show a differently
cropped version as the final result.

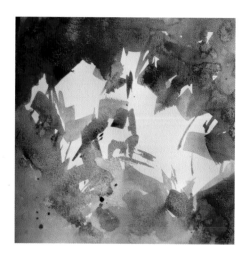

An abstract diagonal shape is applied with two colours.

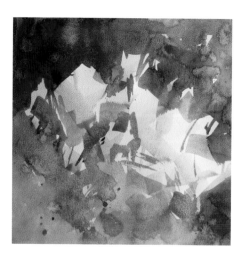

The white area is shaped to some extent with a few splashes of blue.

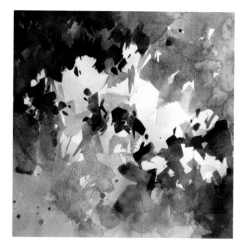

Dark splashes in red and blue are applied from the top left to the bottom right in order to reinforce the pattern of tonal values.

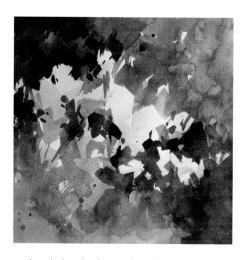

A detail clearly shows the abstract elements in this work.

Direction

The diagonal direction is a determining factor for the whole picture here.

TIP:

Aim for a mix of figurative and abstract elements. For one individual this would be twenty per cent figurative to eighty per cent abstract, for another completely the reverse. You are free to choose.

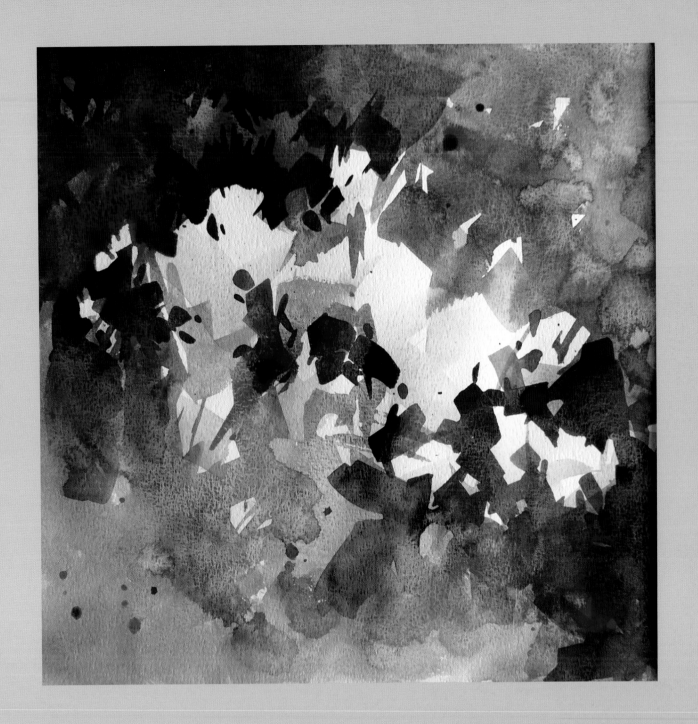

This spontaneous, fresh approach leaves
much to the viewer's imagination.

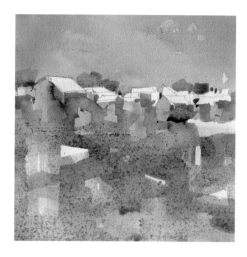

The basis is once again a sketch, as simple as possible, intended solely to mark out the white blanks.

A foundation is laid with a simple palette of three colours (phthalo blue, alizarin and raw sienna).

The colour value is intensified a little here and there. Take care that each colour is repeated elsewhere as a response.

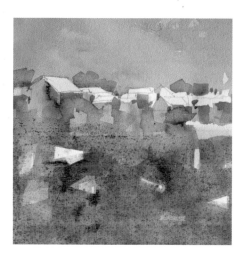

More raw sienna is applied to the base, creating the effect of space.

Unity

Every element is repeated as an echo elsewhere in the work.

TIP:
The abstract quality is increased by focusing in and grouping, bringing shapes together instead of portraying scattered objects.

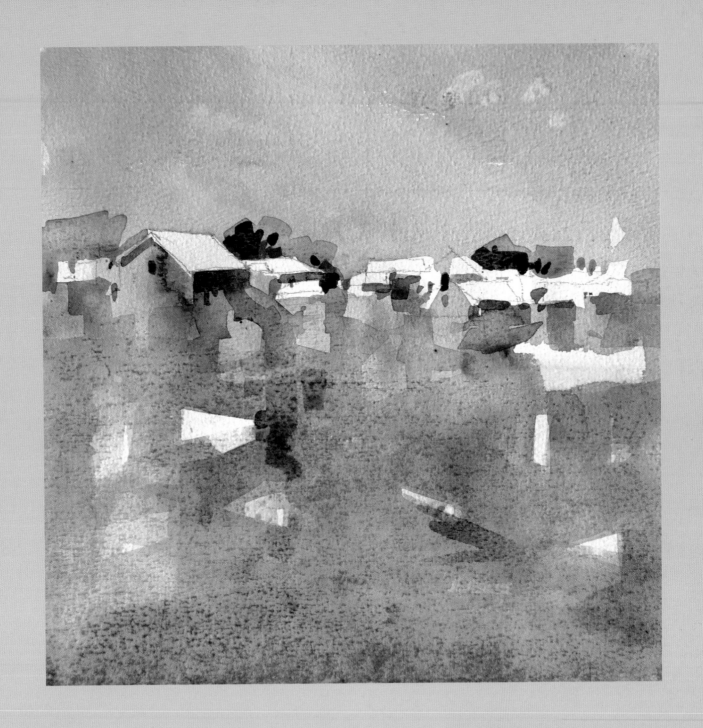

Finally, I apply some more dark accents to emphasise the light horizontal shapes.

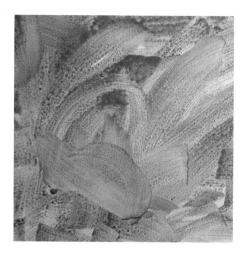

I apply a violet base using a hog-bristle brush and acrylic paint.

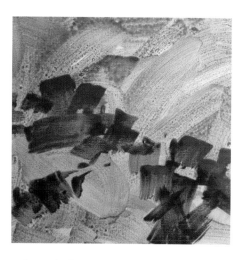

A few splashes with a flat brush already provide character at the initial stage.

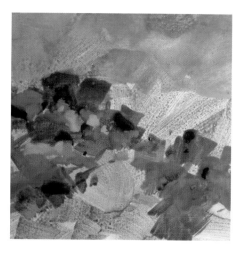

A few yellow ochres provide a contrast effect.

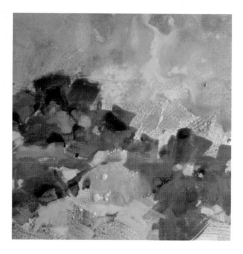

I add a bit more colour to the violet base. Notice the diagonal movement too, providing dynamism.

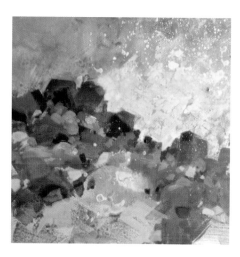

The abstract picture now evokes for me a suggestion of rocks in the surf.

Dominance and harmony

The violet underpainting gives harmony to this work.

TIP:
Always try to put a dynamic diagonal in your work and balance this with an opposing diagonal as contrast.

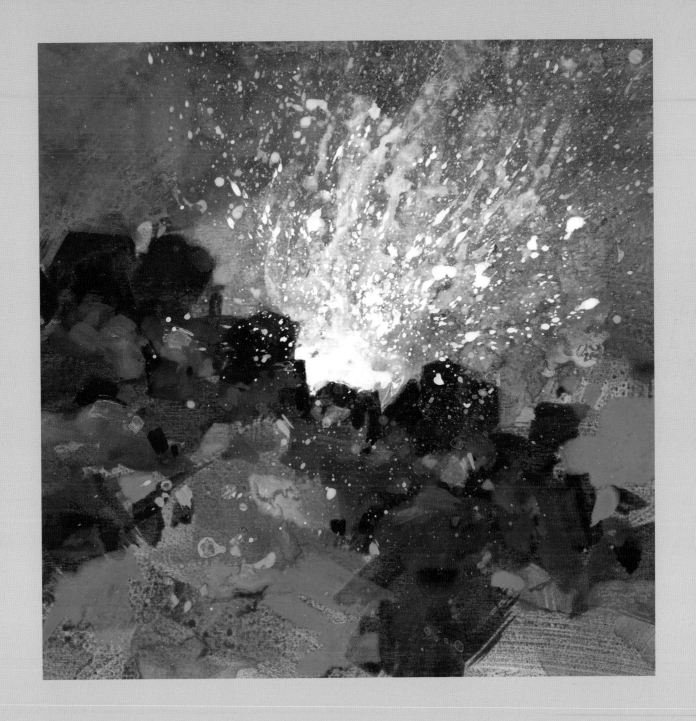

I reinforce this suggestion with some white, diagonal spatterwork, and
then it is finished!

A base in violet, phthalo blue and olive green to set the atmosphere. Echo or repeat the colour elsewhere in the work.

In order to give it some texture, you could apply some kitchen foil to the wet paint, for example, and leave it to dry.

Next, a concise drawing is made to provide an anchor.

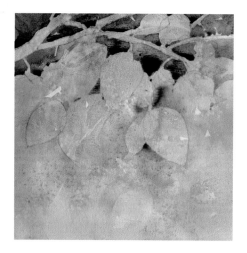

A suggestion of branch and leaf shapes, with the tonal contrast concentrated at the top.

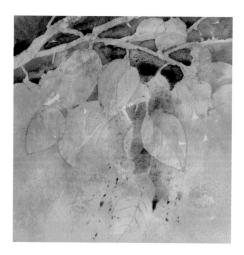

A vertical contrast is applied to offset the dominant horizontal movement.

Texture

Texture enriches areas of a painting that are too flat and dreary.

TIP:

Texture can be created in all sorts of ways. Dry brushstrokes or textured ground, spatterwork, salt, etc. But too much texture destroys the unity and harmony of the work. Again, opt for too little rather than too much texture. Pay more attention to compositional elements, such as contrast and balance, than to so-called reality.

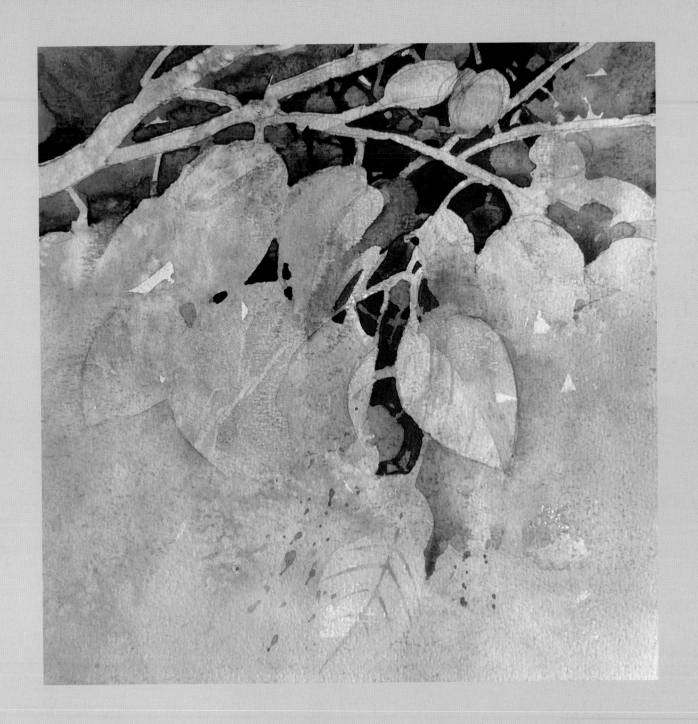

This is strengthened further in the last stage by adding more tonal difference.

A base of blue and burnt sienna applied with a hog-bristle spalter brush.

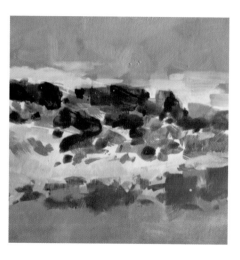

A few indigo blue splashes are enough to evoke a suggestion of rocks on the beach.

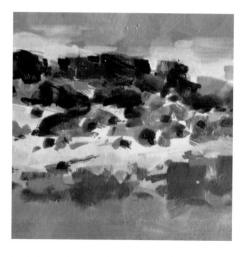

I reinforce the tonal contrast with a few more accents.

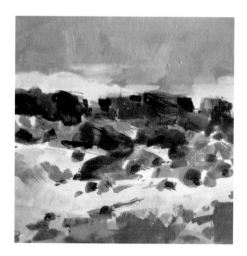

I explore the composition using my two L-shaped cards.

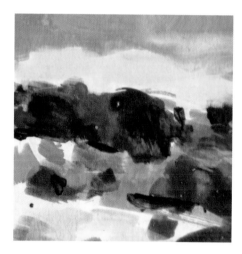

I focus in a little further with the L-shaped cards.

Contrast

Tension between the elements makes a picture dynamic and interesting.

TIP:
Tonal contrast is one of the most important elements for bringing a painting to life. Without light and dark tones, the work remains flat and unappealing.

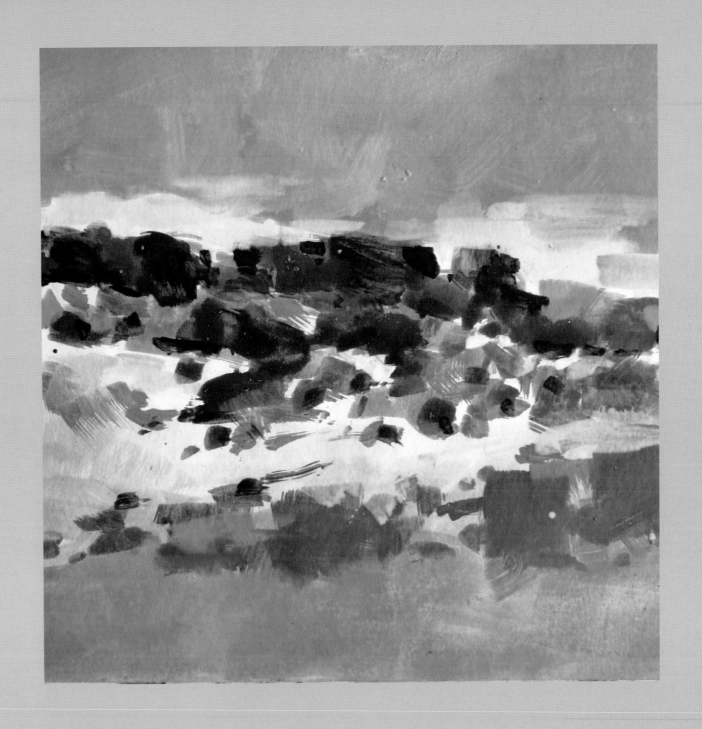

But I finally decide to use the whole picture for the end result.

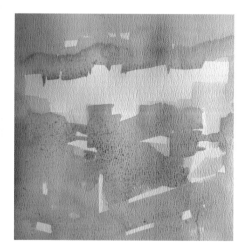

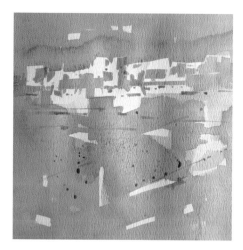

Balance

In addition to balancing tone and colour, you should also ensure an equilibrium between quiet and active parts of your work.

A beautiful abstract pattern and harmonious colour palette are vitally important for the initial phase.

The large white silhouetted pattern is broken up a little so that the whole picture acquires more form.

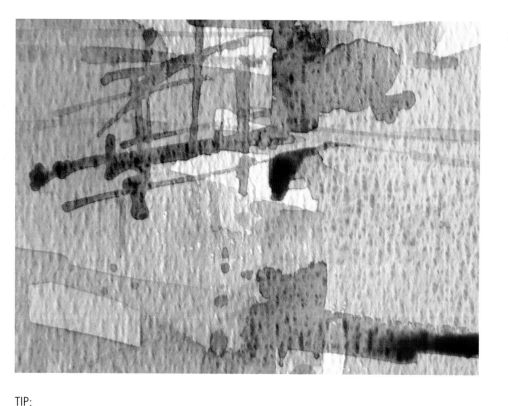

Kees van Aalst
Watercolour detail

TIP:
Leave plenty of empty space in your composition: at least half of the design of the initial phase should still be visible in the final phase.

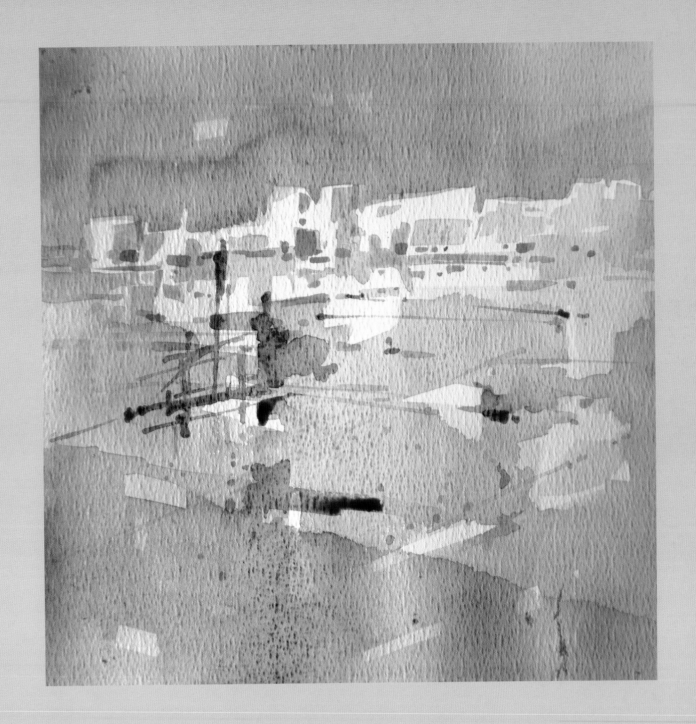

The foreground and background are linked
with a zigzag movement.

A base is created once more using acrylics in orange/sienna. A hog-bristle spalter brush was used.

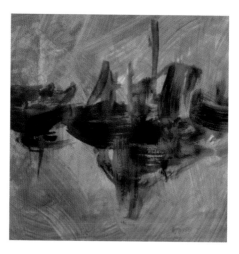

A horizontal is applied in a dark tone with a smooth, calligraphic gesture.

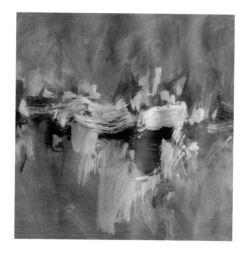

The addition of lighter blue and ochre-white splashes still leaves room for interpretation as either landscape or harbour.

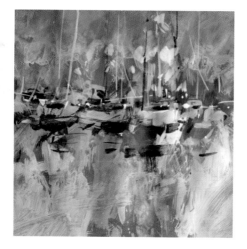

I opt for the latter and emphasise the suggestion of boats by applying some vertical strokes with a thin brush.

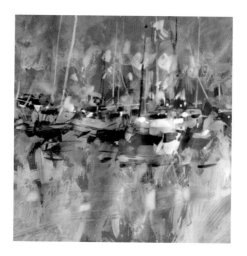

Adding a little more colour increases the vitality of a busy scene like this.

Proportion

Proportions will influence the total picture. If we focus in, the proportional relationships change.

TIP:
Surprise yourself during the painting process and let the subject develop gradually instead of starting from a given reality.

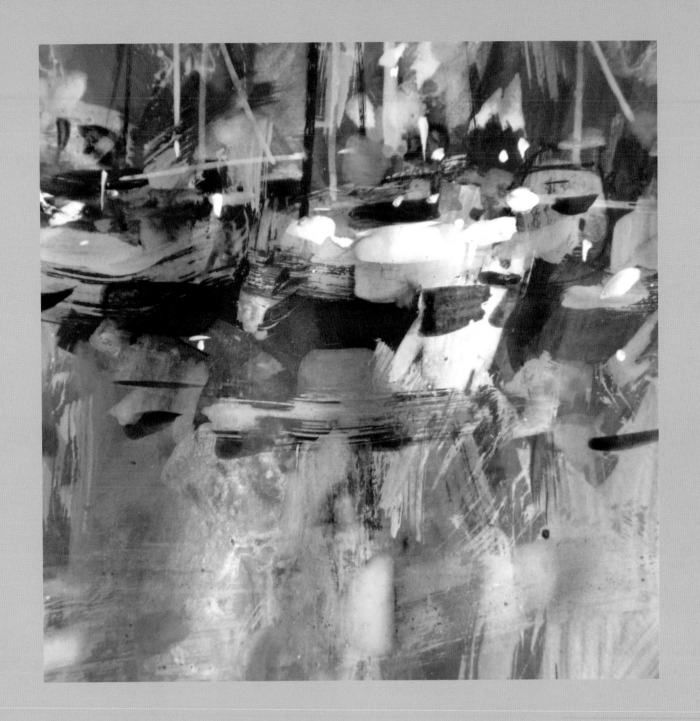

The L-shaped cards are useful once again as we decide
to focus in slightly on large shapes.

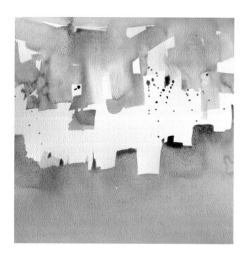

Without having a picture in mind as yet, I put some fairly large shapes on the paper with a flat brush.

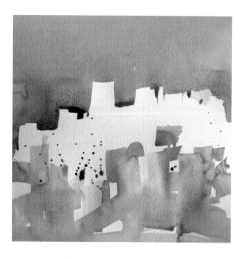

By turning the paper, I start to see the suggestion of a subject.

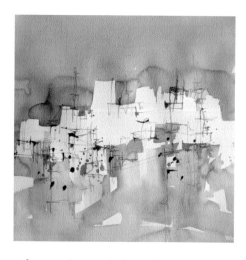

A few pen lines with thinned paint reinforce the illusion.

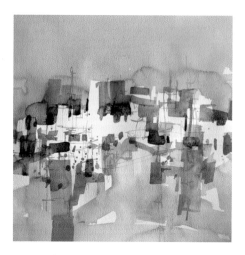

Dark halftones give the subject substance.

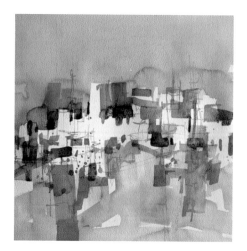

A detail shows the abstract basis even more clearly.

Line

Linear elements liven up a composition.

TIP:
Ensure you alternate between quiet and active sections. Limit the activity to the focus of attention.

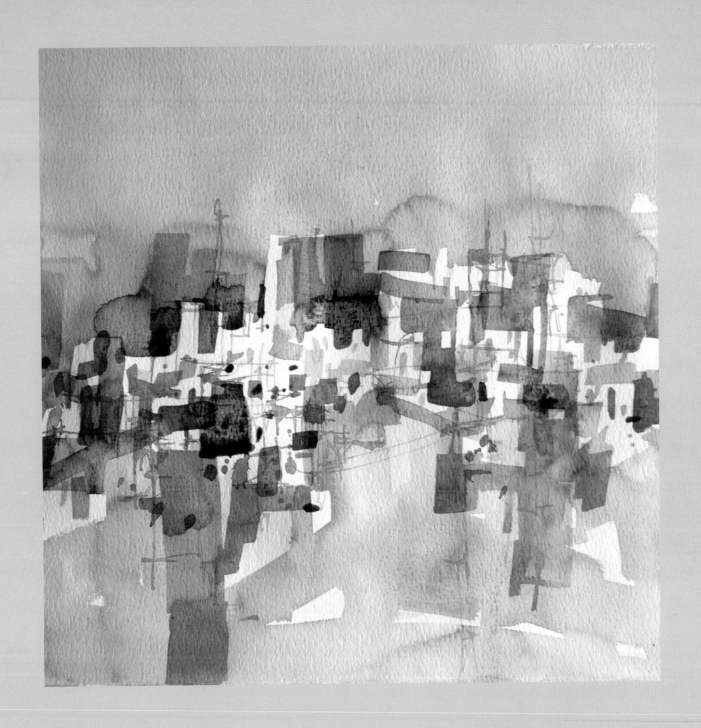

In a picture like this, the atmosphere is more important than photographic accuracy.

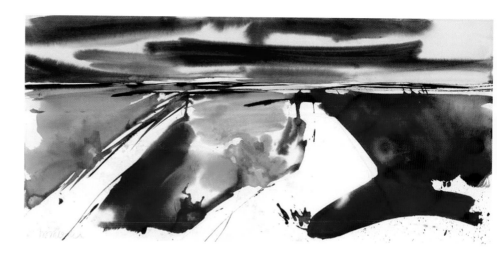

How do I learn to lie?

Between image and reality

The existence of different styles in figurative art suggests a distance between picture and reality. Even photorealists will interpret the same subject differently. A difference in accent here, a nuance of colour there and you would immediately recognise the style of even those artists who are most true to nature.

There is no reality without interpretation. Art is not simply about technique; it also allows the artist's character to be expressed through his or her paintings. It is not just what you paint (reality), but in particular how you paint (composition and signature) that are important. Alongside mimesis – the imitation of reality – natural forms are turned into art by means of stylisation, increasing tension and abstraction.

This semi-abstract approach can also conceal a drawback. Many people who cannot draw will throw themselves into semi-figurative art instead of training themselves in the art of drawing.

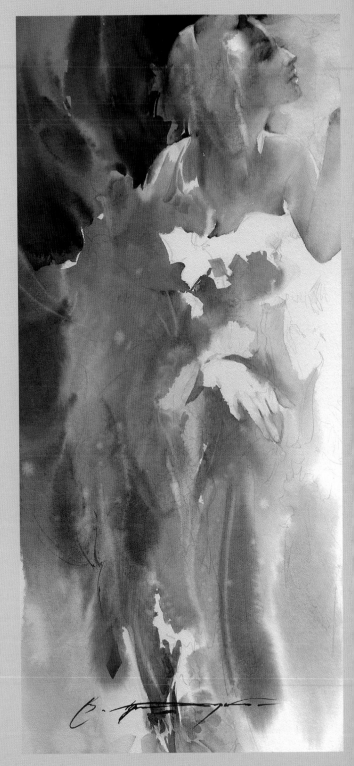

Slawa Prischedko
Watercolour
The work of this artist rises above the level of a pretty picture thanks to the contrast between the decorative and figurative elements.

All the plastic arts sit between the two poles of the non-figurative (Mondrian, Pollock) and the realism of Dürer or Helmantel. We can find figurative art with an abstract, simplifying tendency in between these two, on a seamlessly sliding scale. The technical skills required for the more realistic approach also serve as a firm basis for developing an abstract approach. In good art, reality is subordinated to composition. A successful realistic painting takes its value not just from the illustrative function but, in particular, from the function that we could call the abstract side of figurative art. This does not mean that we must always keep to a strict compositional scheme. Such an approach can result in dull rigidity. For many painters, chaos and serendipity are ideal starting points to set the imagination working. Leonardo da Vinci advised his apprentices to throw a paint-soaked sponge against the wall and project pictures on to the paint mark, as one does in the Rorschach test. Picasso had a heap of rubbish lying in one corner of his studio and often stared at it to stimulate his imagination and suggest new ideas. Max Ernst also used chance in many of his works. We can compare this approach to a painter who paints a vase of flowers, reproducing a single flower explicitly and indicating the others with suggestive strokes. This 'pars pro toto' (part representing the whole) approach contributes to the vitality of the picture.

People do not experience reality in the same way. Everyone sees his or her own reality as a result of different experiences and different ways of processing them. As a painter, you can play on this by depicting parts of your painting in a looser style, more like a suggestion. The viewer can then allow his or her imagination free rein. The incomplete sections will then act as a screen on which the viewer can project his or her own subjective picture. Many prefer suggestion to realistic representation. They would rather project, would rather have the pleasure of analysing and guessing the meaning. That meaning may be different for each person, and may even change over time for the same person.

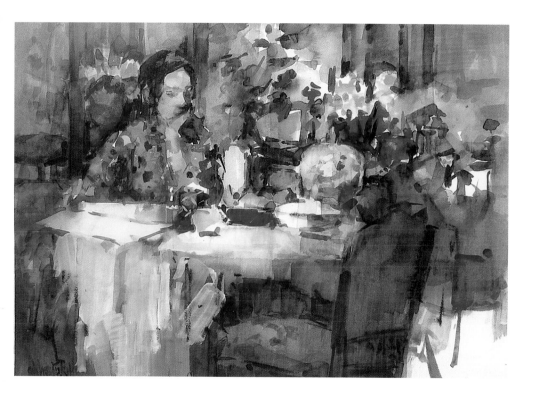

Rob Houdijk
Watercolour
Reality is subordinated to the composition here. A good painting is more important than the accurate representation of reality.

Suggestion

It is just like the Rorschach inkblot test: you see what is kindled in your own mind, not necessarily what the painter deliberately puts there. But a sort of collaboration can easily develop between the creator and the viewer.
To make daubs is to suggest ideas. Blots set the imagination to work. Close up they are meaningless; at a distance they come to life. When offering the viewer a variety of possible interpretations, the painter has to provide some guidance; he or she has to provide a handle enabling the viewer to interpret the painting in ways they suggest. By putting more detail in one section or by means of the title, he or she essentially restricts the viewer to certain options of interpretation. This suggestive manner of painting is far more adventurous and interesting for both the artist and the viewer than the extremes of pure figurative or abstract art.

The relationship between the objects – the composition – is more important than an accurate depiction of reality. Constructing a balanced pattern of tonal qualities forms a solid basis for a successful composition and thus for a successful work of art. Simplicity is the key word here. Be selective, eliminate surplus detail and release yourself from slavish adherence to reality. Add something, leave something out, change something. In short, learn to lie. Avoid too many tonal contrasts at the edges of the painting. Restrict yourself to halftones here. The stronger contrasts should be located in the central section, at the point to which attention needs to be drawn. A strong light–dark contrast is an outstanding means of drawing attention to the main subject. As a painter, you are an entertainer; you have to keep your audience pleasantly occupied. Look upon the painting as a play with you as the writer, director and interpreter. No small task, as you will see.

Viktoria Prischedko
Watercolour
A splendid mix of realistic and abstract elements.

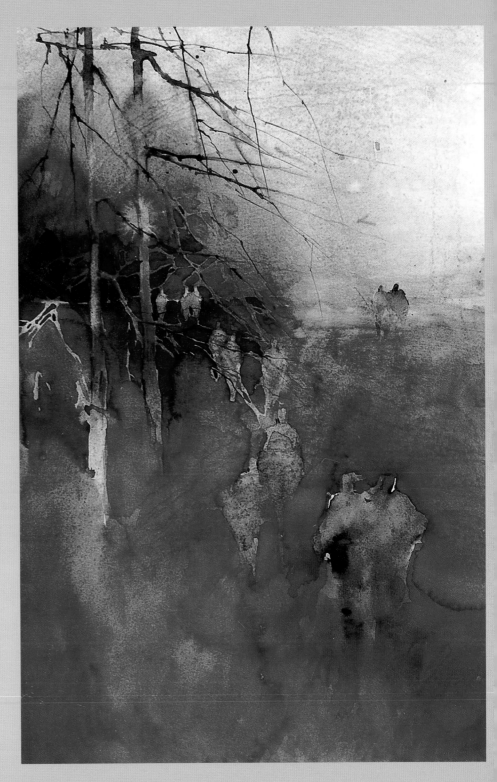

Planning

Many paintings fail before the brush has made a single mark on the paper, just because there has been no planning or preparation. The result is often a number of fragmented shapes with no visual connection. It is vitally important for the unity of your painting that you do not leave a specific shape, tone or colour in isolation but repeat it elsewhere as an echo. This is how unity and variety are created. The abstract principles of cohesion and variation need to be distilled from the reality. Details that draw the attention away from these elements are simply left out.

Simplicity

Simplification is the key word for producing a successful work of art. The paradoxical combination of opposing ideas is a prerequisite for a good composition.
Repetition and alternation, simplicity and complexity, clarity and obscurity are contrasts that will give the work power and tension. They will provide your work with vitality and rhythm.
These oppositions need one another if they are to be brought into harmony. Otherwise it would lead to monotony or chaos.

'Simplicity in art is not at all simple to achieve.'
Otto Weiss

Xavier Swolfs
Watercolour
This composition of horizontals and verticals creates a poetic picture.

138

Piet Lap
Watercolour
*A powerful abstract pattern gives
this painting an expression
that rises above reality.*

You will gradually have come to understand that the mental approach to the subject of realistic abstracts is more important than the technical. To underline this philosophical approach it is important to look at the same material from different angles or in a different context, which I hope will help clarify the concepts involved.

'A drawing that is set down on paper with a few lines in a few minutes may be just as complete in itself and just as good as a painting on which a painter has worked for years.'
Max Liebermann

Ingrid Dingjan
Watercolour
More suggestion than reality. This leaves
room for the viewer's imagination.

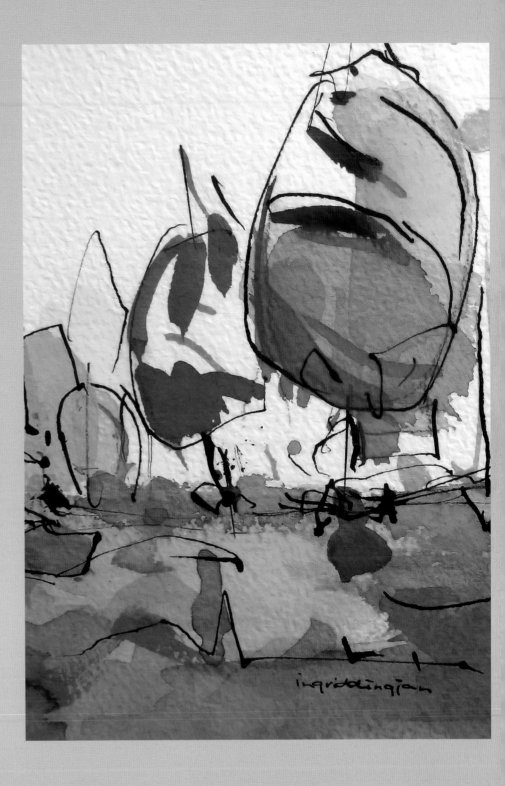

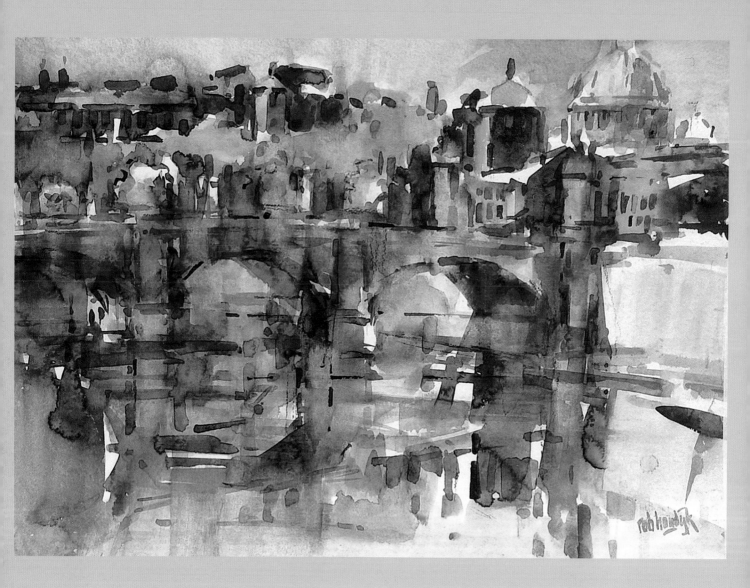

Rob Houdijk
Watercolour
A splendid interplay of colourful touches
blends this picture into a unified whole.

Slawa Prischedko
Watercolour
The decorative abstract shapes are more
important than the representation of reality.

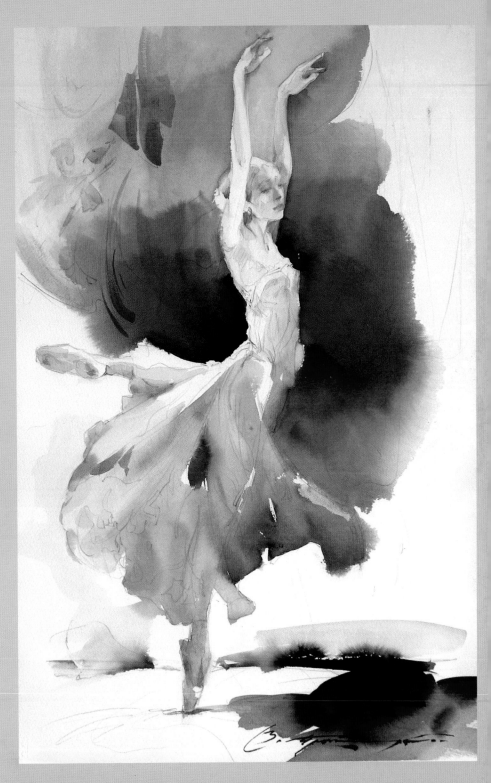

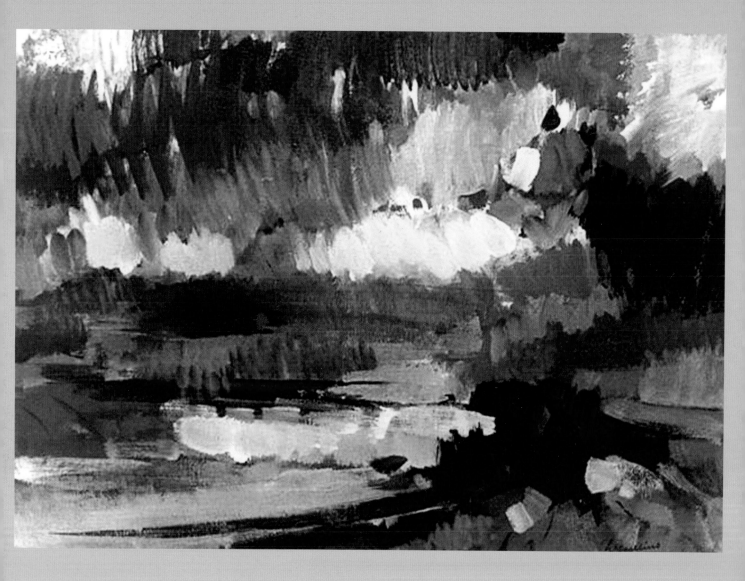

Jacques Wesselius
Acrylic
Varied tonal values are reproduced here with
a lively touch. Notice the vertical movement
of the brushstrokes as a contrast to the many
horizontal lines.

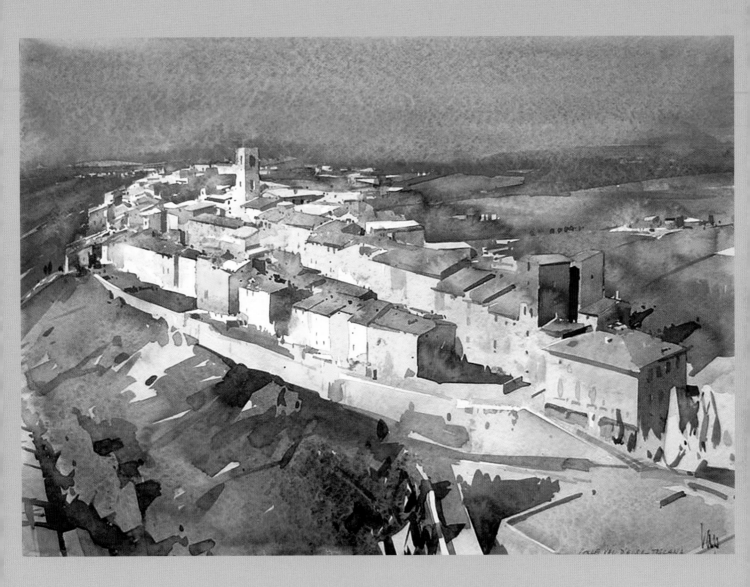

Piet Lap
Watercolour
*The diagonal movement of the main theme
gives this watercolour great vitality.
The figurative approach has a powerful
abstract basis.*

Xavier Swolfs

Watercolour

Like no other, Xavier Swolfs is an artist who has perfectly mastered the combination of the figurative with abstract art and the illustrative with decorative aspects.

Viktoria Prischedko
Watercolour
*Precision and suggestion are combined
here with artistry.*

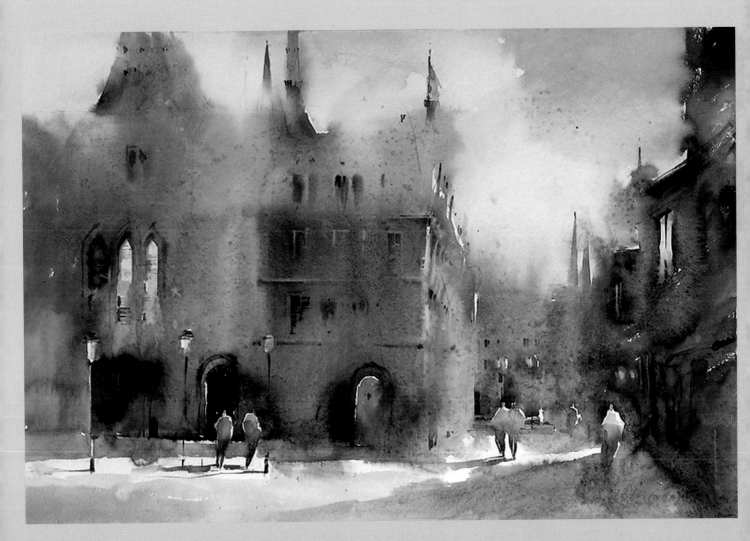

What next?

Tips and tricks

Now that you know a bit more about the most important principles of composition, we can get down to work. Like me, you will probably have work that has never been completed for one reason or another. You were not satisfied with it or did not know how to progress with it. Use the principles I have listed as a checklist now to put that picture to the test. Why is it not interesting? Too little tonal contrast? Too many fragmented shapes? Too dull or too chaotic? Using the checklist and some common sense, we will now be able to rescue much of that apparently failed work and bring it back to life. Try to assess the work as objectively as possible as if it had been done by someone else. Do not be discouraged or say 'There is nothing to be done with this' but set to work analytically. What is wrong here and how can I improve it? I will set out a few important problems and solutions below.

Problem	*Solution*
Tonal quality too much in halftones creating a dull, lifeless picture.	Add one or more light shapes and let them contrast with darker sections.
Large areas with too little activity so that the main subject fades into the background.	Use your two L-shaped cards to reduce the picture area and pare it down so that the main subject takes up the optimum position in the picture.
Too much activity so that the whole impression is chaotic.	Combine detached shapes using the same tonal or colour value. Focus in and reduce and crop the picture area. Paint out disorganised sections with too much activity, particularly at the edges of the picture area.

Kees van Aalst
Watercolour

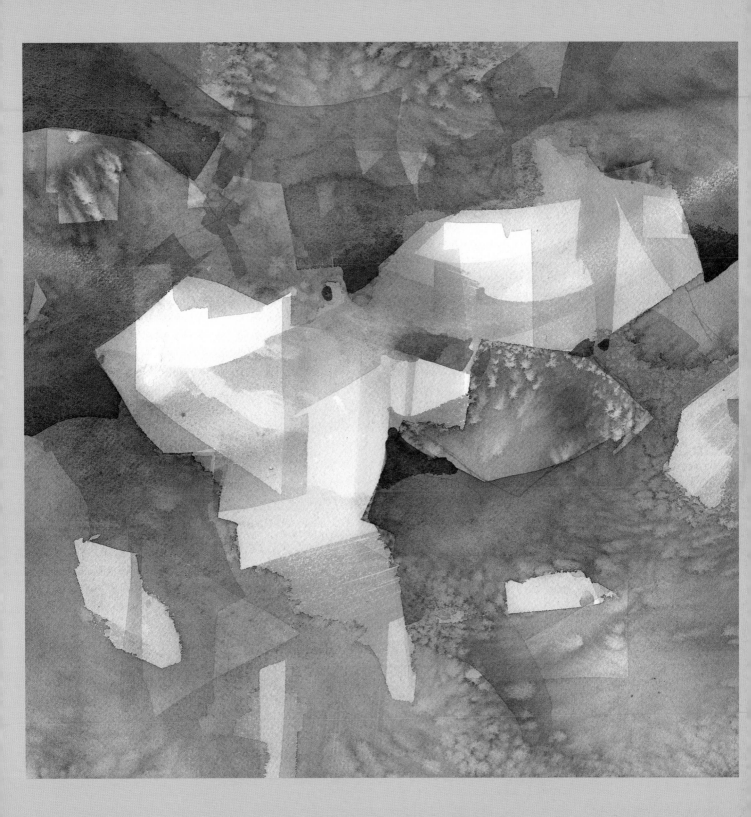

You can do this in various ways:

1. On watercolour paint, wash out sections using a sponge or hog bristle brush and water.

2. On watercolour paint, use a glaze to apply a thin layer of transparent colour over a section that is too busy, so as to acquire more calmness.

3. Use white gouache or poster paint, possibly mixed with watercolour paint. Apply a transparent or opaque layer over areas with too much activity. Experiment with this.

4. You can also use gesso or acrylic paint to combine messy areas and achieve cohesion.

Short checklist to help you analyse and improve your work

Have I provided enough tonal contrast?

Is the strongest tonal contrast concentrated at the focal point?

Have I also ensured that there is some contrast in shapes and directions?

Have I repeated elements, such as form and colour, sufficiently elsewhere in the work?

Have I also applied sufficient variation in the elements to avoid dullness?

Are the left and right sides of the work balanced?

Have I alternated between still and busy sections?

Are there some linear elements as well as the surface areas to enliven the work?

Have I limited my use of colours?

Have I tried not to narrate too much in a single painting but kept my story simple?

Kees van Aalst
Watercolour

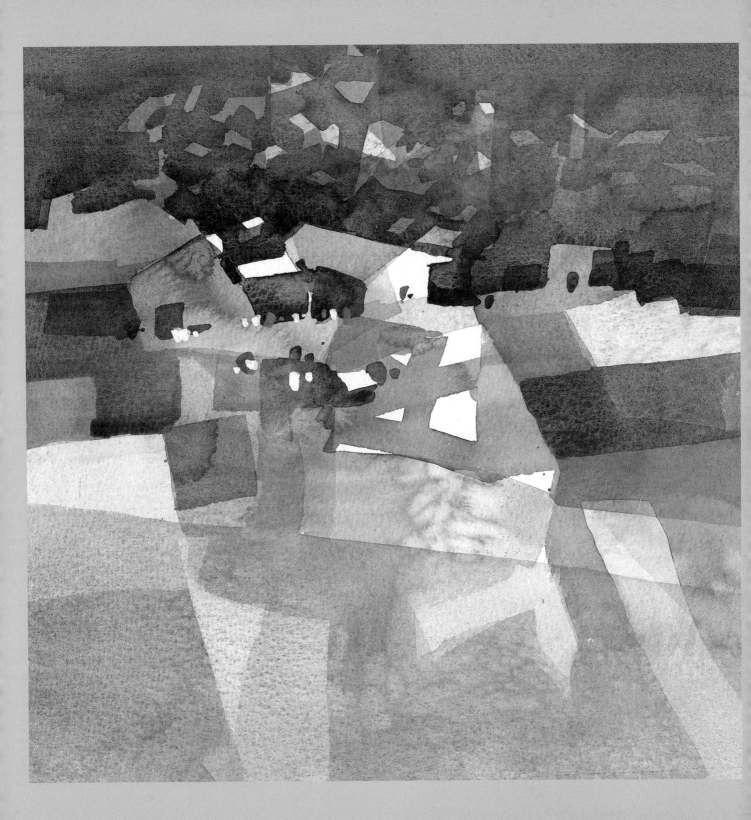

Towards a style of your own

Illustrating and writing are two methods of saying something about reality. The expressive artist uses line, colour and material as the symbols of his or her code; the author makes use of the marks of writing.

Agreement

These code symbols used by the expressive artist and the author do have to be based on agreement if we are to consider them as a form of communication. No picture or text has an intrinsic meaning; even if the interpretation appears clear, it still needs to be reinforced by the creator. Reinforcement comes from both the painter and the viewer; they have mutually agreed to ascribe a meaning to the picture. The meaning of a symbol does not therefore depend on its form but on the agreement between those using it. Such an agreement is essentially arbitrary: any meaning can be placed on a symbol. For example, we could call a chair a table and vice versa if both parties agree to do so. All forms of secret writing are based on this principle. They are incomprehensible to the uninitiated – but that is the whole point.

Abstract art

An expressive artist also needs these agreed symbols in order to be able to communicate. The more widely these symbols are understood, the more contact the artist can make with his or her audience. But for some people there is something crude about this easy communication: in the same way as an arts expert distinguishes between literature and light reading, or between classical and light music, he or she also makes a distinction between expressive art and decoration or illustration. Art then becomes less easy to access and demands more imagination. Of course, abstract art is more susceptible to this than figurative work. So, can we not conceive of any symbols that touch everyone in the same way, without agreements having been made about them? I doubt it. For example, a specific writing style may be seen by one person as fluent while another will consider it sloppy, and we have not even started to agree on the content of the text. If the content, for example, concerns accuracy, then form and content may contradict one another and obstruct any feeling of harmony. The writer is powerless. He or she is unable to change his handwriting but will have to change his subjects in order to achieve harmony. It is not exactly logical, is it?

Visual art

The same fate awaits the visual artist. Through years of practical experience, he or she has developed a specific style; his or her own handwriting. This style, the external form, evokes different responses from different viewers, depending on their own background and nature. The colours and forms say something even if they do not represent anything. For one person they will be powerful elements, full of character, while another sees something aggressive and challenging in them. The artist himself, who also has a right to be heard, will interpret his or her own handwriting differently again. The assessment of the content of the artwork will also differ from person to person. The artist, who after all has the last word, will give a picture a title that covers his or her own interpretation, particularly if they work in abstract art. If we focus in a little more on the surface of the picture after this somewhat philosophical approach to the total form, we are confronted with the characteristic lines and brushstrokes of the artist.

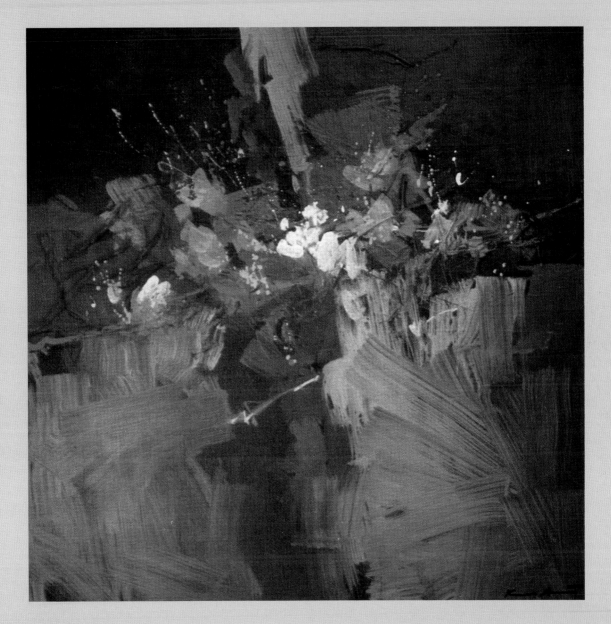

Kees van Aalst
Acrylic

Charisma

Have you ever sighed 'I wish I had such lovely handwriting,' when you come across a writing style that is full of character? Yet such fine writing always deviates from the meticulous classroom models on which it is based. What we can learn from this is that the optimum legibility of the general, impersonal paradigm is later amply offset by a vital personal writing style full of inner strength. What applies to handwriting also applies to the visual arts. The brushstrokes of great artists are like charisma, the expression of personality. That is a gift. But we do not need to give up; there is still a great deal to be learned.

Brushstrokes

A painting is made up of brushstrokes. These may be weak and uncertain or strong and full of self-confidence. They are often more important than the actual subject. The experienced viewer looks behind the picture and sees the expression, the charisma, the soul of the work, which is made visible through the brushstrokes. This is the reason that so much abstract work comes to grief. Because the figurative is missing here, the whole of the viewer's attention is monopolised by expressive aspects, including the nature of the brushstrokes. Much abstract work falls down here; it can attract painting without ability, like the guitarist who fancies himself a musician as soon as he has mastered a couple of chords.

Distorted reality

Abstract art arouses resistance in many people: associations with unskilled depictions posing as art.
'My little boy could do that' is the rule rather than the exception.
Karel Appel, with his statement that 'I just mess about', added more fuel to this particular fire.

Abstraction literally means: withdrawn from reality. If we take this literally, all painting is abstract: indeed, paint on canvas or paper is never identical to what is depicted. Take, for example, the title given by Magritte to one of his works: 'Ceci n'est pas une pipe' (This is not a pipe). He had, in fact, drawn a pipe but it was not a real pipe. Let us expand our definition of painting to include representing an illusion of reality. But what is reality? A so-called non-figurative painter, who entitles a work 'Fear' or 'Hope', for example, is reflecting on an inner reality in doing so. Can such a work still be called abstract? For that matter, simple paint on canvas or paper without any meaning is also a reality, in that it is what it presents. Paint on canvas, viewed in this way, is not abstract at all.

Weak brushstroke with little contrast.

Strong gesture expressing energy. Notice the internal structure of the stroke.

Zigzag movement too even; a lifeless, dull shape. Also inadequate tonal and structural contrast.

Lively brushstroke, resolutely drawn with fine tonal and structural contrast.

Sterile weak shape, too hesitantly drawn.

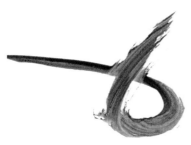

An expressive brushstroke, full of self-confidence and with an energetic gesture.

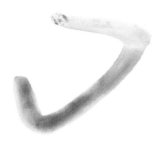

Brushstroke too hesitantly applied so that it has no power or dynamism.

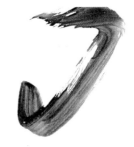

A resolutely drawn, lively brushstroke, with a fine structure.

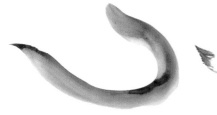

Sterile, weak shape, too hesitantly drawn.

A flowing, powerful flourish, expressing movement and dynamism.

Lively strokes

A brushstroke in which something happens breathes vitality. This demands variation in direction, texture and tonal quality. In short, the energy of the gesture must be expressed in the stroke. This can be strong and graceful but also dead and flat. Experience will allow you to develop a feel for lively strokes.

155

We would therefore do better to abandon the distinction between the abstract and the figurative. Like everything else in our dualistic thinking, we are on a sliding scale here: light–dark, high–low. What I call high as relative to one thing, someone else might rightly call low as relative to something else.

So what can one gain from theories? In the field of suggestive, less illustrative art, we can benefit greatly from theories. The meaning of a line, a shape or a colour surface only develops in the context in which it is placed. For example, you can see in the illustration below (freely adapted from Saul Steinberg's work) that the same horizontal line from left to right changes its meaning depending on the context, and the relationship between shapes.

If you apply this phenomenon to your own work, you could use it to alter relationships in your paintings and confuse the viewer. The impressionists were very good at using this technique. For example, the same types of brushstroke could be used to show both the people attending a racecourse and bottles of spirits in the interior of a café. Only the context determined their meaning. So leave something to the imagination; allow the viewer to complete the work him- or herself. With a loose style of painting like this, your work will be very much appreciated. If, for example, you paint a landscape in an abstractive process, you suggest the majority the scene, then use a few calligraphic accents at the end to give the viewer a handle on better understanding the subject.

This method of working will give your work its own signature and will create more pleasure for both you and the viewer. You can see that abstract painting then no longer involves simply 'playing with paint' but gives your work added value by calling on the imagination of both the creator and the viewer. Although the viewer will not always interpret what he or she sees correctly, they can be assured that they will never be bored again! He or she can keep guessing ad infinitum and even mentally complete 'unfinished' sections as a sort of Rorschach test for art viewers.

The meaning of the continuous horizontal line
changes its character from left to right.

In conclusion

I hope that you have enjoyed reading this book, and that it has encouraged you to approach your painting in a looser style and to distance yourself further from visible reality. Maybe it will stimulate you to experiment more and so add depth to your work. The freedom of expression that is the basis of this book will hopefully inspire you to find your own approach and your own style. The great variety in the work of the contributing artists will have illustrated how much the artist's writing 'style' determines the specific character of their work. Do not worry about letting yourself be influenced by others to begin with. Later, as you develop as an artist, you will find your own path.

Although this book offers stimulation and support, courses and workshops, where you are painting with like-minded people, also constitute a huge incentive to continue on your artistic journey. Together with fellow participants, you will inspire one another and develop in leaps and bounds. I wish you every success in this.

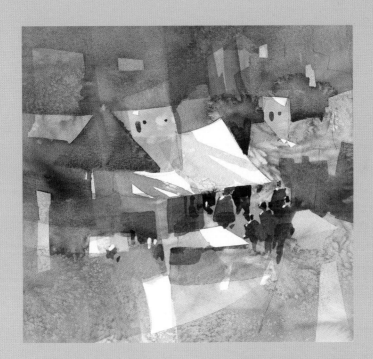

Contributing artists

Cao Bei-An
Pages 89, 91 and 105.

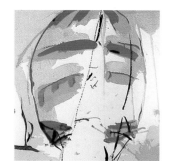

Ingrid Dingjan
Pages 102 and 141.

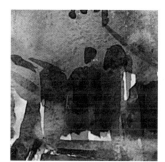

Rob Houdijk
Pages 79, 97, 136 and 142.

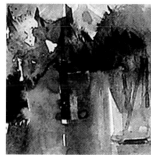

Piet Lap
Pages 11, 65, 84, 95, 140 and 145.

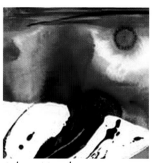

Johan Meeske
Pages 13 and 132.

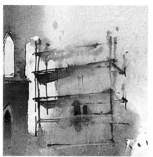

Viktoria Prischedko
Pages 7, 21, 137 and 147.

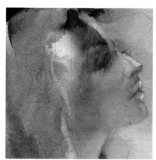

Slawa Prischedko
Pages 103, 133 and 143.

Xavier Swolfs
Pages 9, 83, 135, 139 and 146.

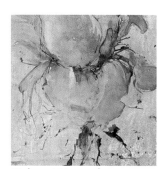

Heleen Vriesendorp
Pages 87 and 99.

Kees van de Wetering
Pages 85, 90 and 101.

Jacques Wesselius
Pages 5, 77, 86, 93 and 144.

Kees van Aalst
All other pictures.

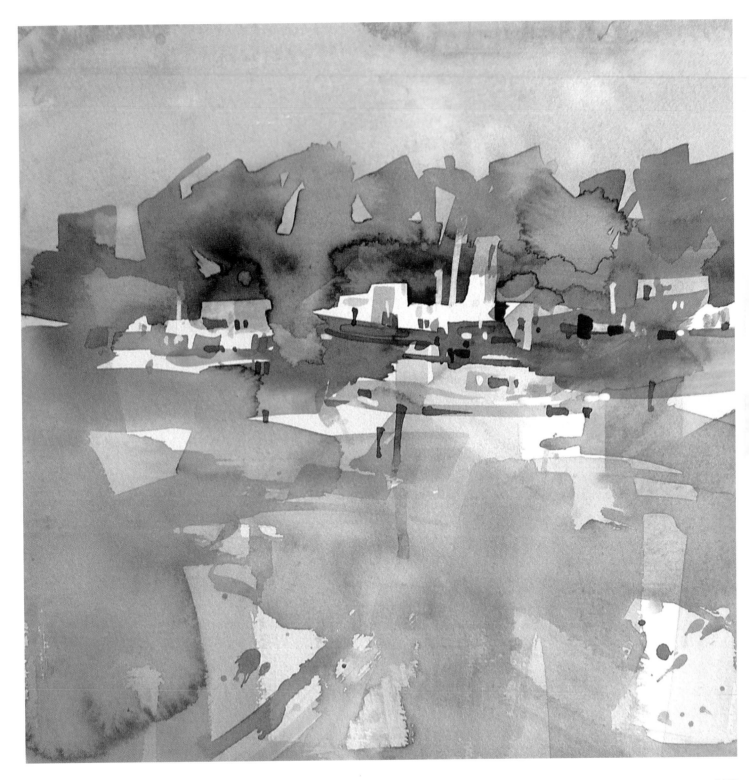

First published in Great Britain 2010 by Search Press Limited,
Wellwood, North Farm Road, Tunbridge Wells, Kent TN2 3DR

Originally published in Holland as *Abstraheren is te Leren: abstract realisme* by Arti, Alkmaar

English translation by Cicero Translations Ltd

English edition edited and typeset by GreenGate Publishing Services, Tonbridge

ISBN: 978-1-84448-560-4

Printed in China